SECRET BRACKNELL

Marion Field

AMBERLEY

To John Bassett who has been so helpful in the writing of this book.

First published 2016

Amberley Publishing
The Hill, Stroud
Gloucestershire, GL5 4EP

www.amberley-books.com

Copyright © Marion Field, 2016

The right of Marion Field to be identified as the
Author of this work has been asserted in accordance
with the Copyrights, Designs and Patents Act 1988.

ISBN 978 1 4456 5142 2 (print)
ISBN 978 1 4456 5143 9 (ebook)

All rights reserved. No part of this book may be
reprinted or reproduced or utilised in any form
or by any electronic, mechanical or other means,
now known or hereafter invented, including
photocopying and recording, or in any information
storage or retrieval system, without the permission
in writing from the Publishers.

British Library Cataloguing in Publication Data.
A catalogue record for this book is available from the
British Library.

Typesetting by Amberley Publishing.
Printed in Great Britain.

Contents

Introduction

My first introduction to Bracknell was when I returned from teaching abroad and needed a post in England. I scoured the advertisements in *The Times'* education supplement and found a suitable role in Ranelagh School. I applied for it, had an interview and was delighted to be appointed. Of all the schools in which I have taught, Ranelagh has to be my favourite. I enjoyed revisiting it recently and immersing myself in the very comprehensive, well-organised archives.

When I moved to Bracknell, I only knew it as a 'new town' and was not aware of its earlier history. When, therefore, I was invited to write a book on Bracknell's secret history, I was thrilled. I soon realised that the town's heritage was rooted in the distant past. Its roots go back to the Iron Age as evidence of an Iron Age fort has been found. The Romans, of course, made their mark with their road, the Nine Mile Ride, which is still used.

When I had lunch in the Old Manor recently, I was fascinated to see that photos of old Bracknell adorned the walls. Going into another dining area, I was even more surprised to see a portrait gallery of royalty. I had had no idea that kings and queens had graced the area. There was no doubt that Bracknell had a royal connection. At one time, part of Windsor Great Park had been a hunting ground for royalty – from Saxon times until the eighteenth century.

During the sixteenth and seventeenth centuries, roads improved and the wealthy travelled more. Because Bracknell was in a strategic position, a number of inns were built to enable travellers to break their journeys, partake of some refreshment and change the horses that drew their carriages. Bracknell became recognised as a coaching town because of the number of coaching inns it possessed. The underground tunnels linking the inns often provided escape routes for highwaymen, including Dick Turpin.

During the nineteenth century the town developed even further. A market was established and this attracted visitors from the surrounding villages. When the railway was built, the town's popularity grew and by the end of the century, it was a flourishing market town. On one occasion Queen Victoria visited the Red Lion but perhaps she only stopped there so that her coachman could change the horses.

After the Second World War, Bracknell was designated as a new town but some of the old inns survived and are now Grade II-listed buildings. Elizabeth II has visited the town on several occasions.

As I delved into the past, I unearthed some interesting facts. As well as royalty, other celebrities have visited the town. Alexander Pope moved to the area from London because of ill health and wrote some of his famous poems while living there. Percy Bysshe Shelley also visited briefly. The town has also produced a few unsavoury characters like the evil landlord of the Hind's Head Inn. Some of the older buildings are even said to be haunted.

Bracknell today is definitely a new town with modern amenities but, in the twenty-first century, it is in the process of being regenerated once again.

1. History of Bracknell

While today Bracknell is primarily known as a new town, there are indications that the area was inhabited in prehistoric times. There is a Bronze Age burial mound at Bill Hill near Downshire Way, but the earliest settlement was at the Iron Age hill fort at Caesar's Camp near the Nine Mile Ride, which was probably built by the Celts sometime during the fourth century BC. Iron was very useful to them as they used it for making ploughs, hammers and other tools. The hill fort could easily be defended and it also kept their animals safe from prowling wolves.

Tradition suggests that Julius Caesar may have camped near Caesar's Camp but the actual name was not used until the eighteenth century. The main road, built later by the Romans, was called the Devil's Highway by the locals as they thought only the devil could have constructed such a thing. The road goes over the woodlands to the south of Bracknell. Excavations in the nineteenth century showed signs of a Roman settlement in Wickham Bushes south of Caesar's Camp. Here, there was evidence of both wooden and stone houses. A little later, Cynegils, King of Wessex, was said to have had a palace in Easthampstead and entertained King Oswald of Northumbria there.

It was not until AD 942 that the name 'Braccan heal' or 'Braccen-Hal' (meaning 'bracken-covered secret place'), first appeared as a boundary landmark on an Anglo-Saxon charter. There is a tradition that the land had once belonged to a man called Bracca, who was possibly a Danish chieftain, but there is no evidence that the area was inhabited at the time. In 1958 a new Bracknell secondary school was given the name Brackenhale.

Easthampstead was originally called Yethamstede, meaning 'homestead by the gate'. The 'gate' would have been an opening which allowed the deer to move out of the area. The whole area around Bracknell later formed part of Windsor Forest. In the eleventh century, William I designated the area around Easthampstead as a deer preserve and it became a popular royal hunting ground for many centuries. It appeared in the Domesday Book (1068) but Norman clerks spelt the name incorrectly as 'Lachenestede'. Over the years, the name gradually changed until, by 1535, it had become Estehampstead. While Domesday did not mention a church in the area, worship would certainly have taken place and in 1159 a charter refers to a church at 'Jexhamstede' where the monks could 'observe and venerate the Festival of the Blessed Edward the Confessor'. Worship continues on the same site today, but the church was rebuilt in the nineteenth century. The royal connection with Easthampstead continued until the seventeenth century when Charles I gave the manor to one of his ambassadors in gratitude for services rendered. Easthampstead remained part of Windsor Forest until 1813.

In the late eighteenth century a turnpike road was constructed from Ascot Heath to Reading. As this passed through Bracknell, the various coaching inns became very busy as travellers stopped to change their horses. Bracknell became known as a coaching town.

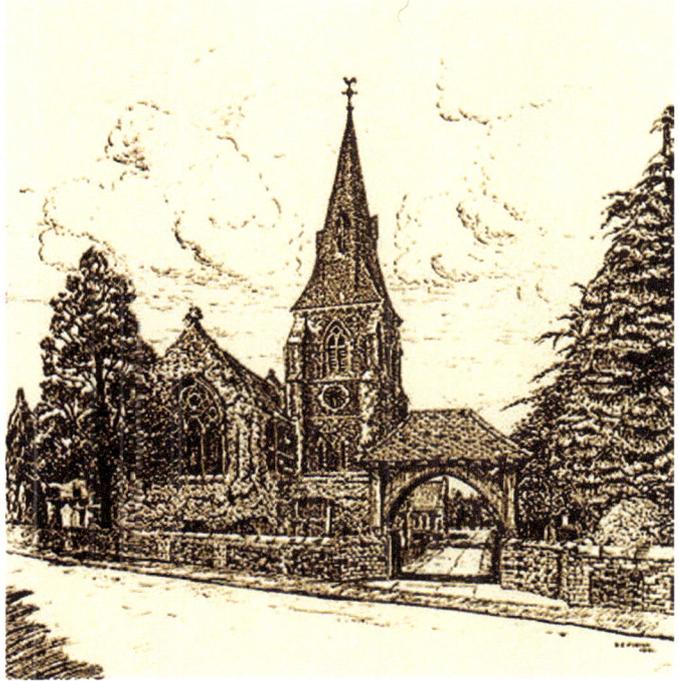

Right: Holy Trinity Church.
(Courtesy of Eileen Briggs)

Below: Holy Trinity Church.

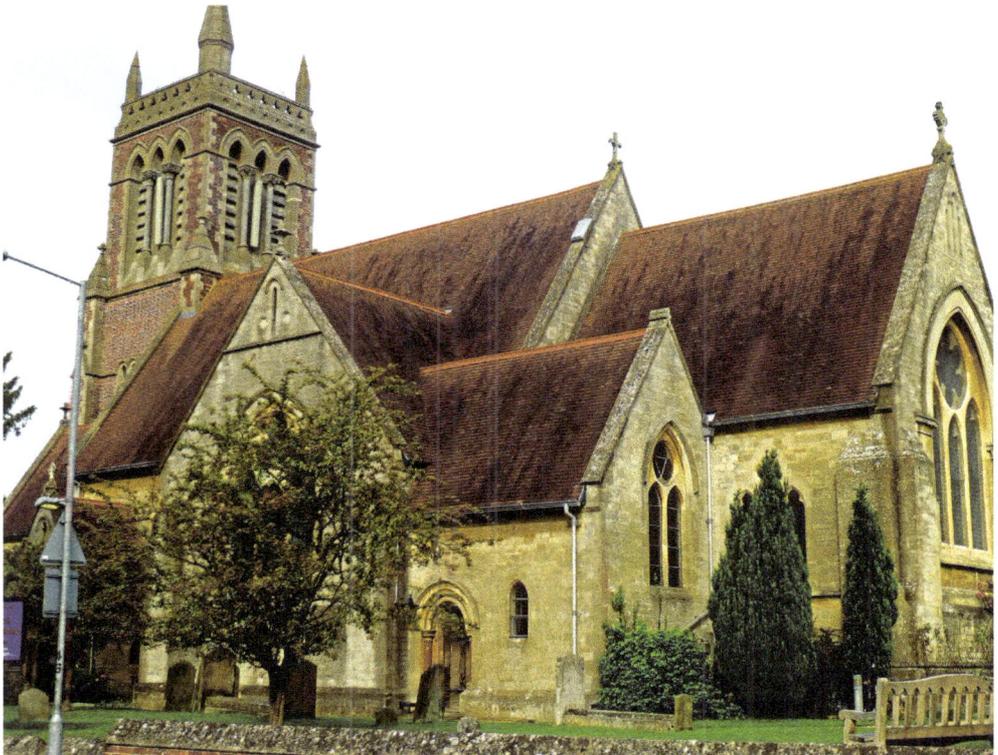

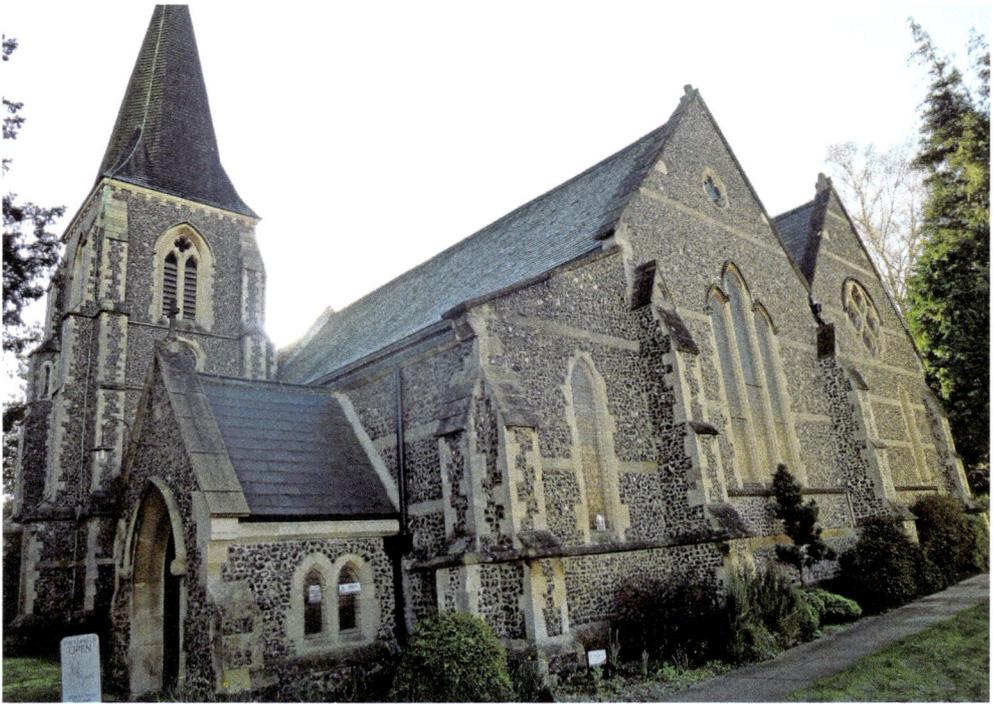

Holy Trinity Church.

DID YOU KNOW THAT...?

In 1864 the Roman Catholic community in Bracknell met in a 'tin hut' which became known as St Joseph's Church. Architect Anthony Sargeant designed the present church in 1956 using roof tiles produced in Bracknell. The building was finally completed in 1962.

The area around Easthampstead was also ideal land for army training, and military camps were often pitched there. George III was known to have visited the area on several occasions to review his troops. In 1792 military manoeuvres involving 7,000 men were held near Wickham Bushes. The only remaining evidence of this is a number of shallow trenches.

While Easthampstead flourished under royal patronage, the town of Bracknell did not develop until later. In the seventeenth century Bracknell Street, which became the High Street, was identified on maps. John Norden, a sixteenth-century cartographer, did a survey of the Windsor Forest area in 1607 and produced a map of the area. On it 'Old Brecknoll' and 'New Brecknoll' were identified. By 1790 buildings had been built on each side of the street and, by the middle of the nineteenth century, Bracknell had developed

into a small village. According to an 1847 entry in Kelly's Directory, it consisted of 'a long narrow street inhabited principally by small shop keepers'[1].

In 1851 the Ecclesiastical Parish of Bracknell was created and Holy Trinity, the first parish church, was built in Church Road on land that had originally been part of the grounds of the Hind's Head Inn. The first incumbent was Revd John Sabin and, on 26 February 1851, the bishop of Oxford, in whose diocese the new parish lay, conducted the service of consecration. Most of the beautiful stained-glass windows in the church have been donated in memory of parishioners. One of them shows St Birinus, who brought Christianity to the area in AD 634. Because of roadworks in the 1970s, the lychgate was moved from its original position in Church Road to its present position.

The small churchyard was used for burials until 1876 but it was not until the 1880s that another burial site was found. The Revd Linzee, a former incumbent, donated a plot of land in Larges Lane for a new cemetery and from 1882 burials took place there. The latest incumbent, Father Guy Cole, was inducted in 2001.

The coming of the railway encouraged more growth and in 1856 a railway station was opened in Bracknell. When a weekly cattle and poultry market was established in 1870, the town blossomed. More shops were established to cater for all tastes and Bracknell became famous for the bricks produced by Thomas Lawrence's factory. The market town flourished and, before the end of the century, the population had doubled. In the twentieth century the town continued to grow in spite of the First World War and in 1920 the market was enlarged.

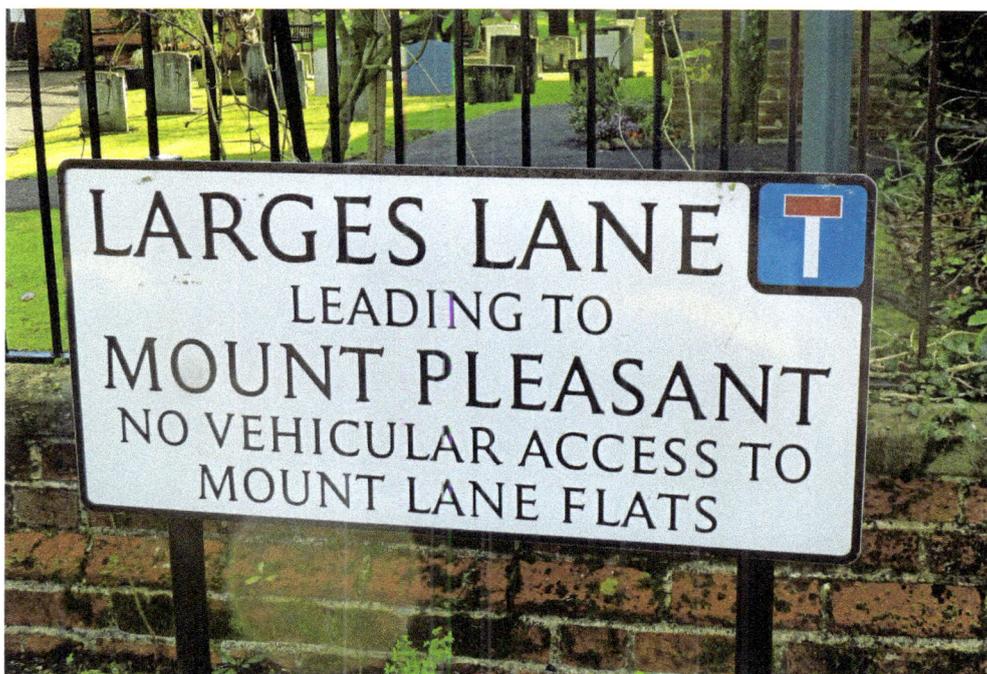

Larges Lane.

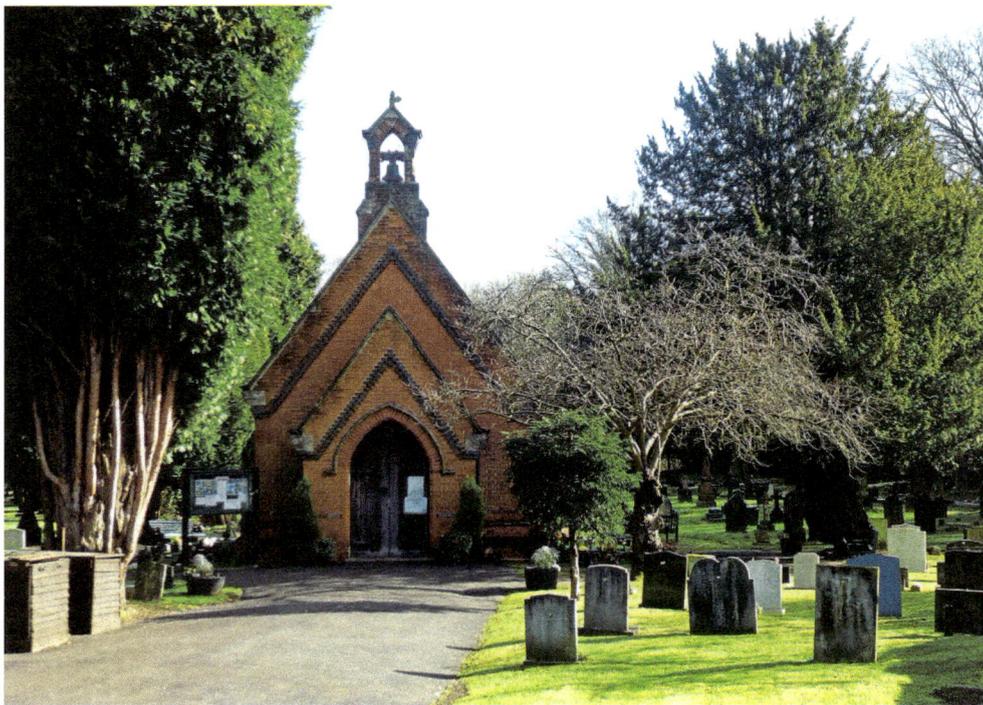

Larges Lane Cemetery with chapel.

DID YOU KNOW THAT...?

The bishop of Oxford, who laid the foundation stone of Holy Trinity Church and also conducted the consecration service, was Samuel Wilberforce. He was a descendant of William Wilberforce who was instrumental in helping to abolish the slave trade.

In 1924, like many other villages and towns in England, Bracknell unveiled its war memorial at the entrance to the town. In the 1950s this was moved and it now stands opposite St Joseph's Church near the town centre.

During the Second World War much of London was destroyed and by the end of the war in 1945, many Londoners had lost their homes. The idea of new towns to solve the problem of overcrowded slums had first been suggested in 1898 by Ebenezer Howard in his book *Garden Cities of Tomorrow*. Attempts to follow his ideas were made at the beginning of the twentieth century. The new town was to be 'a self-contained country town combining the amenities of town life with the advantages of the country'. Some new towns were created at this time but after the Second World War there was an even greater need.

In 1944 the Greater London Plan suggested that ten satellite towns outside London should be built. They should not encroach on the Green Belt or be sited on good agricultural land and

Areas of Outstanding Natural Beauty were also to be avoided. The new town must also have good transport facilities. In 1946 the New Towns Act was passed and sites for new towns were sought. Bracknell was an ideal choice: it was situated on acid soil which was unsuitable for agriculture although the pockets of clay had proved invaluable for the manufacture of bricks, had a railway, and, in 1948 Bracknell was designated as a new town.

At first there was a great deal of hostility to the plan. The small county town objected to the invasion of Londoners but the objections were ignored and the plans proceeded. Resentment increased when the original residents were informed that they were not eligible for the new houses that were being built as the money had been allocated to rehouse the Londoners.

It was in Priestwood, within Easthampstead Parish, that the first fifty houses were built. In 1951 the new residents started to move in. When, in 1953, Elizabeth II was crowned, trees were planted in Queensway to mark the occasion. The following year, ten shops with flats above them were opened in Priestwood Square. Priestwood Court metamorphosed into a pub, The Admiral Cunningham, named after a British admiral of the Second World War. This was officially opened in 1954 by the gentleman himself. The gardens became a children's playground and the first primary school in the new town was opened. By 1957, 178 houses had been built. Brackenhale, the first new secondary school in the parish, received its first pupils in 1958. St Andrew's Church, which had been rebuilt in 1888, was demolished 100 years later in 1998 and the new church was consecrated in 1990. Today it is part of Bracknell's Team Ministry. In 1964 Point Royal, the impressive seventeen-storey block of flats, was completed. It comprised 102 flats and parking facilities in the basement for ninety cars. In 1996 the surrounding area became a conservation area and Point Royal was given the status of a Grade II-listed building.

War memorial.

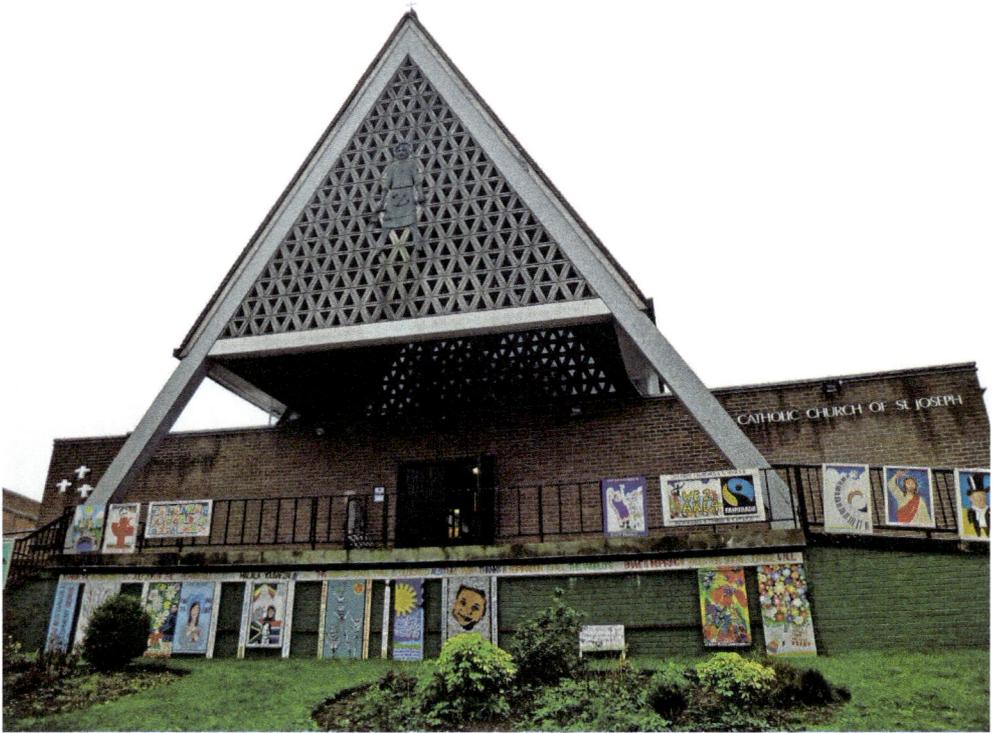

St Joseph's Church.

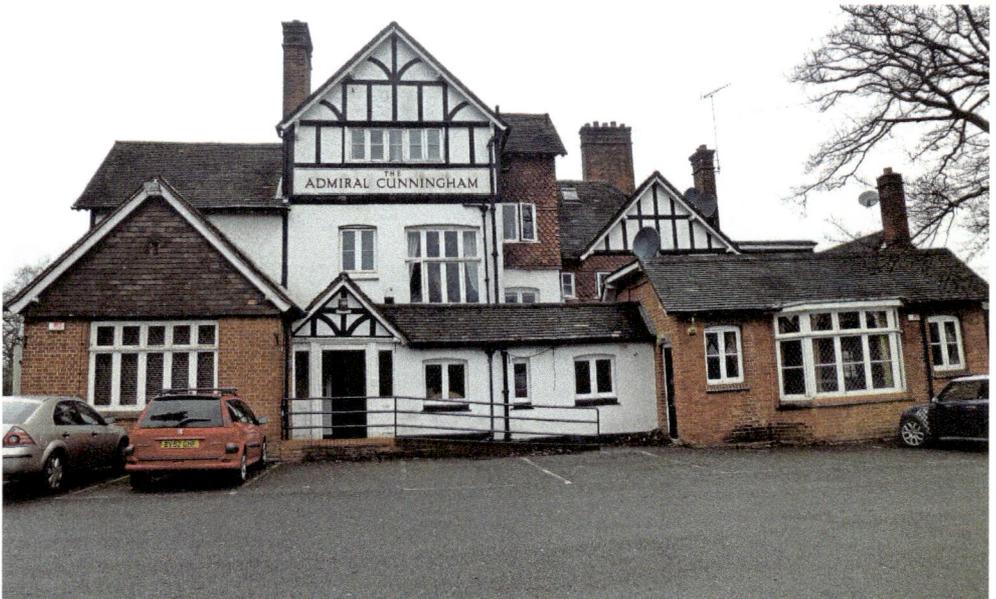

The Admiral Cunningham.

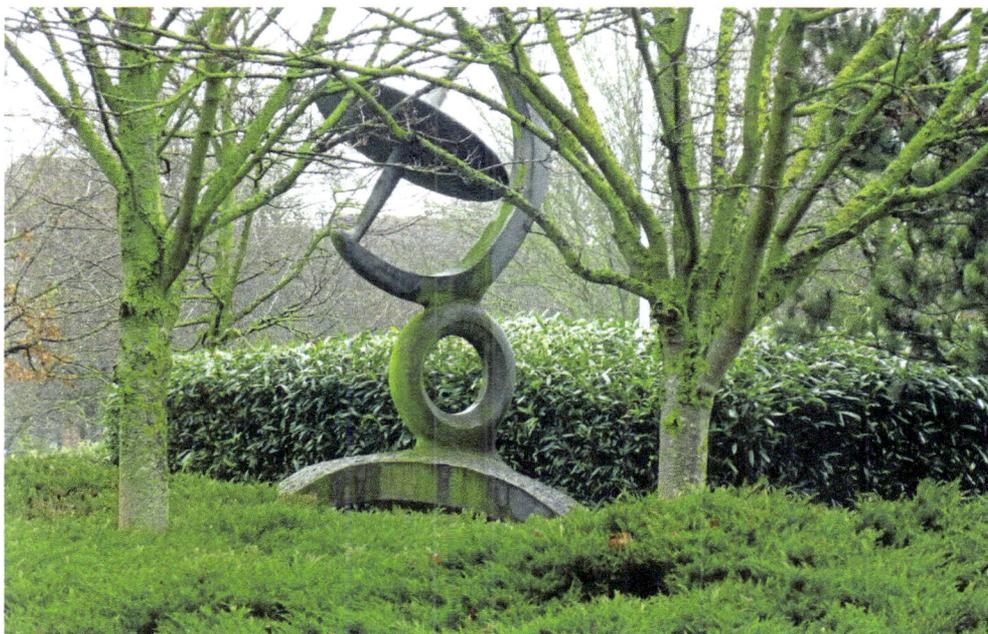

The 'Sperry' sculpture.

DID YOU KNOW THAT…?

In the 1960s Sperry Gyroscope commissioned a 4-metre-high sculpture which can now be seen on the 'Sperry Roundabout' on the Wokingham Road.

Building began in Bullbrook in 1957 and by the following year seventy-two houses were ready for occupancy. A shopping centre soon followed and in 1959 the first purpose-built community centre appeared. In the 1960s, fifty-four private detached houses were built. Crown Wood was the last part of the new town to be developed but it was not until 1978 that this was ready for its new residents.

The Cattle Market continued for some time. During the 1951 exhibition in London, cattle that were 'on show', were later sent to Bracknell to be graded by the Ministry of Food. Bracknell eventually received and sent cattle to Government slaughter houses.

During the 1960s it was decided to extend the new town and Wildridings was developed. Its name originates from the 'Rides' that Queen Anne created when she could no longer ride on horseback. The houses built there were of a higher standard than the previous ones and central heating was installed for the first time. In 1967 the houses were ready for occupation but it was two years before shops were built.

Great Hollands also developed in the 1960s because Sperry wished to extend its Bracknell factory by transferring the Brentford branch to the new town.[2] An interesting

construction, in the middle of a roundabout near the site of the factory, stands today as a memorial. New houses for the employees were ready in 1967. Sixteen shops were opened in 1971 and the first Health Centre in the new town was sited nearby. Another secondary school, Easthampstead Park, opened in 1972. Other estates soon followed and the town centre was extended. By 1981 the population of Bracknell had increased to 49,000.

Another interesting place of worship, the Kerith Community Church, was built in the 1980s. This replaced a Baptist church which had been on the same site in Church Road. The architect who designed it, Stephen Birch, also designed the new Baptist church in Easthampstead. As well as holding regular services, the Kerith Centre, as it is now known, is also available for use by the community. Talented members of the congregation run a variety of creative courses once a month throughout the year and 'New to Kerith' lunches are held on a regular basis. The Kerith Centre has become the hub of the community.

In 1988 the district became a borough taking the name of Bracknell Forest Borough Council. By 1990 the population of the whole area had increased to nearly 60,000. In 1996 Bracknell was described by the council as 'an area of special architectural or historic interest, the character or appearance of which it is desirable to preserve or enhance.' In 1998 it became a Unitary Authority.

Bracknell continued to expand as the Millennium approached. However, with the coming of the twenty-first century, new plans are afoot and Bracknell is now scheduled for regeneration in the future. Work has already started and it is hoped that it will be completed by the spring of 2017.

The Kerith Centre under construction in Church Road. (Courtesy of Pam Jackson)

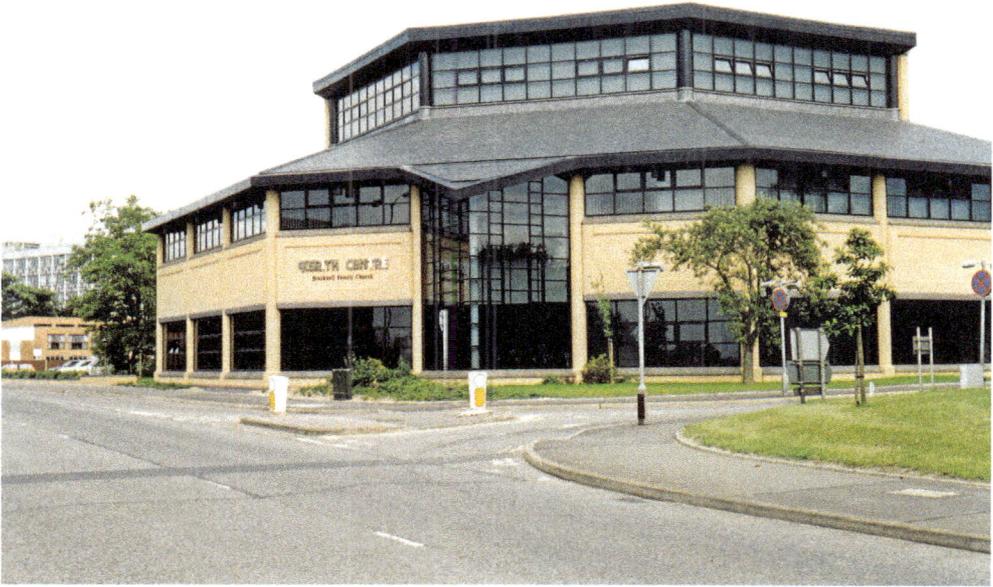

The new Kerith Centre. (Courtesy of Pam Jackson)

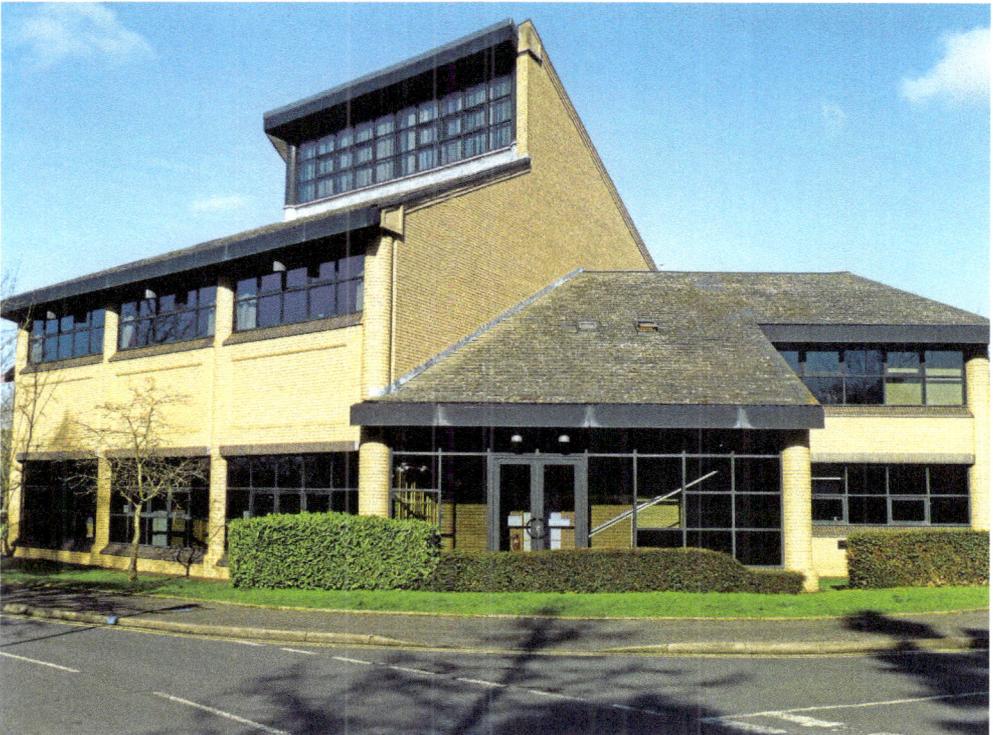

The Kerith Centre, 2016.

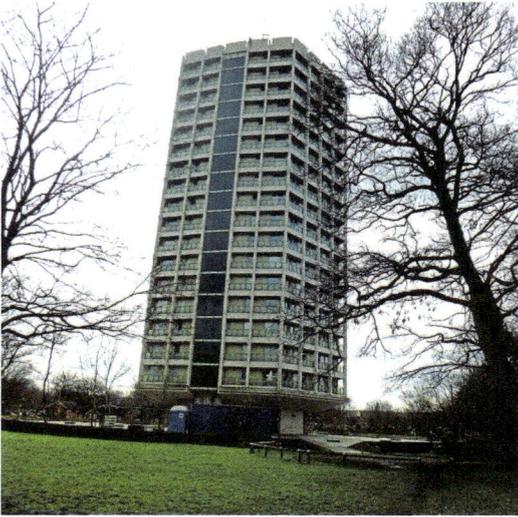

Left: Point Royal.

Below: Flats and shops in Easthampstead.

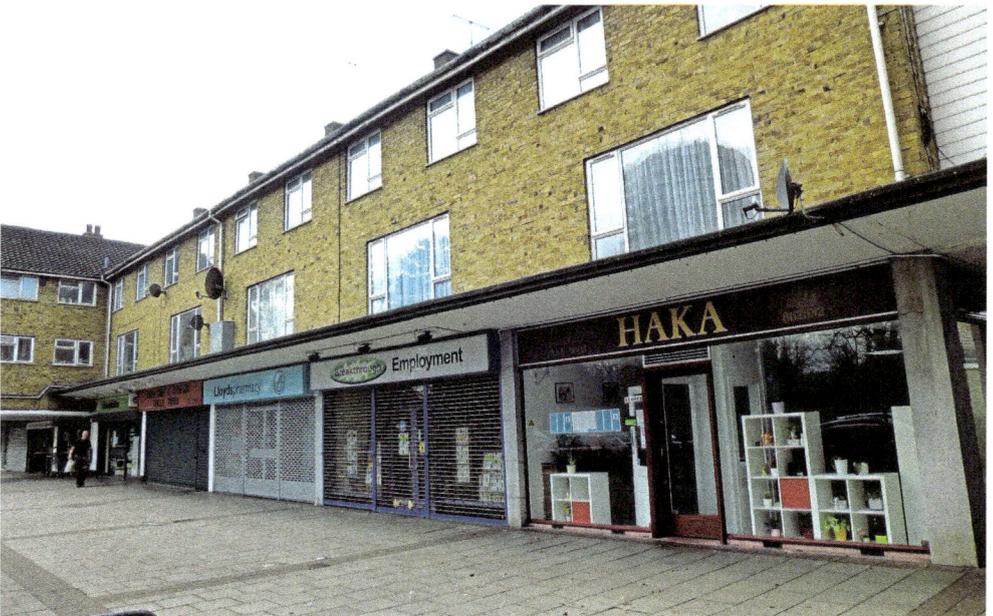

DID YOU KNOW THAT…?

In 1972 Waitrose opened its central warehouse and head office in Bracknell. In 2010 the company planned a new store and work started in April 2011. In November of the same year the impressive supermarket opened. It was the first new store in Bracknell for twenty-five years.

2. The Royal Connection

The Saxons

There is a tale that in the seventh century, Eastampstead Park, was one of the homes of the King of Wessex, Cynegils, who had been converted to Christianity. The area continued to be frequented by the Saxon kings and, in the eleventh century, Edward the Confessor gifted the manor of Easthamstead to Westminster Abbey. Much of the park was only inhabited by deer as the land was reserved for the Saxon kings to enjoy the popular royal sport of hunting.

The Normans

With the defeat of Harold, the last Saxon king, by William, Duke of Normandy, the throne of England passed to the Normans Hunting in Eastshampstead Park continued to be a royal pastime and in 1086 Lachamstead appeared in William the Conqueror's Domesday Book. Over the years the name changed to Yezhamsteda and eventually to Easthampstead.

Like his Saxon forebears, William thoroughly enjoyed hunting. It was said that 'he loved the tall, red deer, as if he were their father'. He encouraged his sons to follow in his footsteps and, during the eleventh and twelfth centuries, the park frequently rang with the shouts of horsemen and the terrified deer could be seen fleeing from their pursuers.

It was to his third son (and favourite), also called William, that the king bequeathed the throne of England and, when he died in 1087, William II ascended the throne. He became known as William Rufus because of his red hair. His older brother, Robert, had been given Normandy by his father. Robert objected to this and there was friction between the brothers. In 1088 William was forced to call on his Saxon subjects to help him put down Robert's rebellion. In spite of his problems, William found plenty of time to hunt in Easthampstead and so did his younger brother who succeeded him as Henry I in 1180.

The Plantagenets

The Norman kings continued to rule until the Plantagenets took over in 1150 with the crowning of the first Plantagenet king, Henry II. Easthampstead Park remained a popular hunting ground but it was not until 1350 that Edward III built a hunting lodge there. He was very attached to the park and was determined that he alone should have the rights to it. He appointed Thomas Foxle as Warden of the Forest, and the Treasurer of the Exchequer was told 'not to inter-meddle henceforward with the Manor of Yeshampstead, because the King has reserved it to his own chamber.'

With the establishment of a headquarters, the king frequently sent decrees and messages from the park. His successor, Richard II, did the same so that the lodge became a hive of activity; he made improvements to the building so that it was a fitting place for him and his family to stay.

Henry VI, who succeeded Richard, was also very fond of hunting and spent a great deal of time in the park as did his successor, Edward IV, who ruled for twenty-one years and gave England a period of relative stability after the turbulent Wars of the Roses.[1]

When he died suddenly in 1483, his twelve-year-old son became Edward V but he reigned for only two months and was never crowned. His disappearance from the Tower of London, where he had been imprisoned with his younger brother, Richard, gave rise to the suspicion that both boys had been murdered by their uncle, Richard, Duke of Gloucester, who had seized the throne to become Richard III, the last Plantagenet king.

He lost his throne and his crown in 1485 at the Battle of Bosworth Field when Henry Tudor, the Duke of Lancaster, invaded England and seized the crown to become Henry VII, the first Tudor king. Richard's remains were recently discovered under a car park on the site of the former Greyfriars Friary Church in the city of Leicester. He was later buried, as befitted a king of England, in Leicester Cathedral.

DID YOU KNOW THAT...?

Henry III was an enthusiastic supporter of bull-baiting and visited the Bull in Bracknell in order to watch this cruel sport.

The Tudors

Like the Plantagenets, Henry VII also greatly enjoyed hunting and introduced the sport to his eldest son, Arthur. They both frequented the lodge and one day, while there, the king proposed a marriage between his son and the Spanish princess Catherine of Aragon. Dutifully, his son agreed to the proposed marriage and it duly took place. Sadly, Arthur died soon after the marriage and the newly widowed Catherine retired to Easthampstead Park.

When Henry VII died in 1509, Arthur's brother, Henry, ascended the throne as Henry VIII. Like all his royal forbears, he too spent much time in Easthampstead in 'search of greater game'. It was said that 'he was in much comfort' as the keepers had promised that the king should have 'great sport' in the park. He often hunted from 9.00 a.m. until 7.00 p.m.. It was while Henry was here that he became friendly with his widowed sister-in-law, Catherine, who was living at the lodge. Henry was attracted to her and married her secretly soon after he became king.

They were a devoted couple; the marriage was recognised and Catherine took her rightful place at court by Henry's side. They were together for over thirty years. Sadly, the marriage turned sour when Catherine was unable to produce a male heir. One of her handmaidens was Anne Boleyn and Henry, always a ladies' man, was attracted to her. She insisted on nothing less than marriage.

Henry was so obsessed with Anne that he tried to divorce Catherine. This was not easy as she was a Spanish princess with powerful relatives whom Henry could not afford to upset. The Church, too, was firmly against divorce. Henry wrote to the Pope saying that he should never have married his brother's widow and requesting the Pope to grant him a divorce. The pontiff refused.

Catherine was not at all happy at the turn of events and refused to agree to a divorce. She retired to the lodge at Easthampstead while Henry continued to find ways to discard his devoted wife. It was not until 1532 that she finally heard the news she dreaded. As the Pope had consistently refused to sanction the divorce, Henry broke all ties with Rome and declared himself 'the Protector and Supreme Head of the Church and Clergy of England'. As such, he announced that he was divorcing Catherine.

He continued to hunt in Easthampstead until his health failed and it became increasingly difficult for him to sit on a horse because of his huge girth. A brilliant statesman, he reigned for thirty-eight years and maintained order in his kingdom without using an army.

When he died in 1547, his only son, Edward, aged nine, was crowned king. His mother, Jane Seymour, Henry's third wife, had died soon after his birth. Edward was very delicate and could never have hunted all day as his father had done. He reigned for six years and, when he died in 1553, with no heir, the country was in turmoil.

Eventually, his half-sister, Mary, daughter of Catherine of Aragon, succeeded him. Elizabeth, the daughter of Anne Boleyn, became the next queen; she was more robust and spent many days happily hunting in Easthampstead Park and staying at the lodge. She was a popular monarch and reigned for forty-four years.

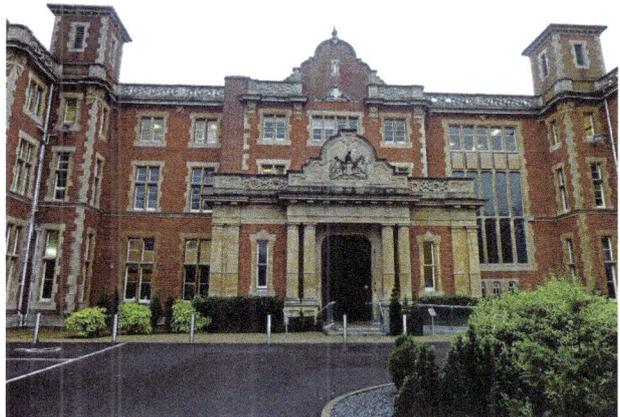

Easthampstead Park Conference Centre.

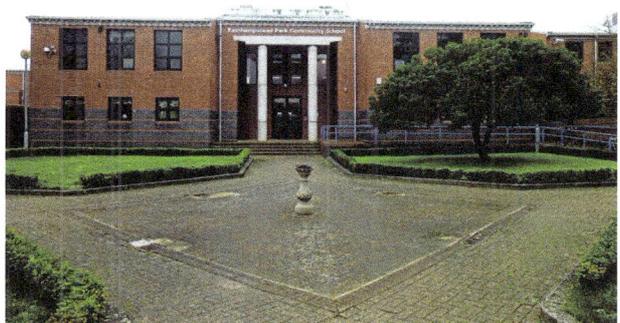

Easthampstead Park Community School.

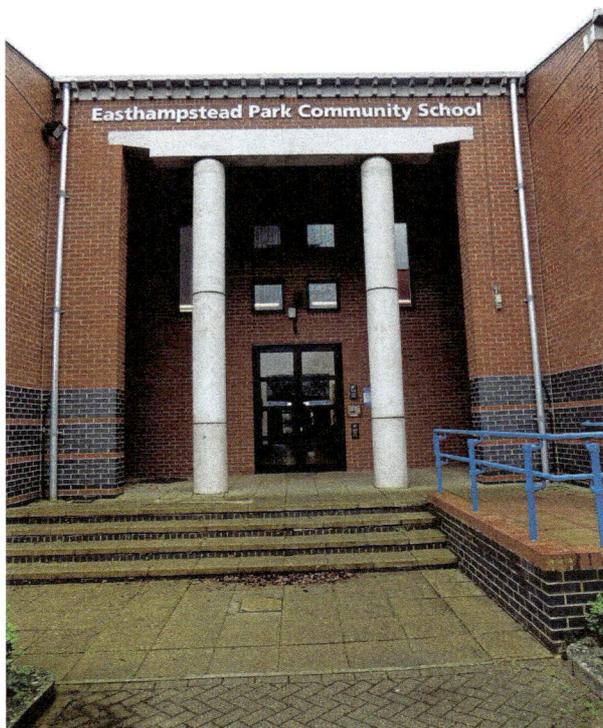

The school entrance.

The Stuarts

In 1603 Elizabeth died without an heir and the throne of England passed to her cousin, James VI of Scotland. When he became James I of England, he united the two countries. He enjoyed his visits to Easthampstead and in 1623 he spent the whole summer there. At the beginning of September of that year, he heard 'a sermon preached at the court, at Easthampstead in His Majesty's last progress'. It was preached by the Revd Warburton, a king's chaplain, on verses from 'Genesis' about Melchizedek, King of Salem. It was a lengthy sermon and, to curry favour, the rector found similarities between the ancient king and the one before whom he was preaching.

It was James's son, Charles I, who brought to an end the direct royal connection with Easthampstead Park. In 1628 he gave the estate to William Trumbull who was ambassador to the court of Archduke Charles of Brussels. It had been a difficult posting and Trumbull had showed great tact and diplomacy. The king's gift was in gratitude of Trumbull's services. However, there was a condition. The new owner was required to keep 200 deer so that the king and future sovereigns were still able to hunt in the park. In 1636 the king issued a charter confirming this gift. This document disappeared for some years but has recently been discovered and is now held by Berkshire Record Office. After the Restoration, Charles II released the Trumbulls from their obligation to provide 200 deer in the park.

The last of the Stuarts, Queen Anne, was also very fond of hunting in Windsor Forest. As she grew older and was unable to ride with the hunt, a number of 'rides' were created throughout the park so that she could follow the hunt in her carriage. The 'Nine Mile Ride' in Bracknell, along which Dick Turpin was later said to gallop, was one of them. In the eighteenth century George III created more 'rides' through the forest so that he, too, could follow the hunt without mounting a horse.

Two Queens

In 1845, Queen Victoria visited the Red Lion in the High Street on her way to visit the Duke of Wellington. Crowds thronged the streets to see her and she was given an enthusiastic reception.

Queen Elizabeth II has visited Bracknell several times during her long reign. Her first visit was in 1962. In 1976 she paid a visit to ICI in the Southern Industrial Area. One of her most memorable visits was in 1978 when she opened the Royal Meteorological Society headquarters. Not only was she given a tour of the new building but she also went on a 'walkabout' in the town centre. Crowds turned out to see her and she met many of the new town's residents. Her last visit was in April 1991 when she opened The Look Out, a Heritage Exhibition. This is now a Science Discovery Centre.

DID YOU KNOW THAT...?

The Victoria Hall was built by public subscription in 1887 to commemorate the Golden Jubilee of Queen Victoria. In 1949 it was the venue for a public meeting to discuss the idea of a new town in Bracknell.

3. Easthampstead

Most of Easthampstead was originally forest, although there is evidence that there were small settlements within the area. Ancient burial sites have been discovered and Caesar's Camp which, in spite of its name, was an Iron Age fort dating from around 50 BC. When the Romans invaded in AD 43, the fort was abandoned.

The Romans left their mark and excavations have exposed the outlines of their settlements; many artefacts have been discovered, including a number of coins. Some of these have been identified as having been minted in around AD 375. As in other parts of the country, the Romans built an impressive road, part of which is still in use. It was called the Devil's Highway by the local people who were convinced that only the Devil himself was capable of producing such a construction.

Later, the area became known as Lachenstede. The manor was owned by Westminster Abbey who had been given it by Edward the Confessor.[1] *Lache* was Saxon for a stream and *stede* was a homestead. The Domesday Book of 1986 stated that the Manor of Lachenstede had five hides but there was no record of a church at that time although it is likely that Christian worship had taken place there.[2] During the next centuries, the name of the area gradually changed to Yetzhamsteda, then to Jeshamsted, and ultimately to Easthampstead. A church was built in 1159 but it was not until 1298 that there is a record of the first Rector, Richard de Budham, being inducted. At that time Easthampstead was within the Salisbury diocese. Some of the rectors are listed on a board at the church but there are gaps in the list. The last one to be inducted was Father Guy Spencer Cole in 2001. Easthampstead was part of Windsor Forest and in 1332 Edward III decided that it would be the perfect place to build a hunting lodge. He therefore confiscated the area from its current owner and constructed his lodge. He ordered the Treasurer of the Exchequer 'not to inter-meddle henceforward with the Manor of Yeshampstead, because the King has reserved it for his own chamber'.

The royal connection with the area continued with Richard III and Henry VII enjoying hunting there. As did Henry's son, Henry VIII, and his granddaughter, Elizabeth. Her successor, James I, stayed there for the whole summer of 1629. He ordered a survey of the area which had a circumference of 5 miles. In this, Easthampstead was described as 'a ground heathie and barren ... It containeth about 265 acres of meane grounde.' The soil was barren but excellent for hunting, which James also greatly enjoyed.

The Crown retained the ownership of the park until 1629 when William Trumbull acquired it. He had been ambassador to the court of the Archduke Charles of Brussels, a difficult posting. In gratitude for his diplomatic dealings with the archduke, Charles I gave Trumbull the gift of Easthampstead Park on condition that 200 deer were kept so that he and future monarchs could still hunt.

Trumbull transformed Edward III's hunting lodge into a luxurious mansion. When he died in 1635 he was succeeded by his son, also called William. This gentleman survived the Civil

Early view of St Michael and St Mary Magdalene's Church, Easthampstead. (Courtesy of Eileen Briggs)

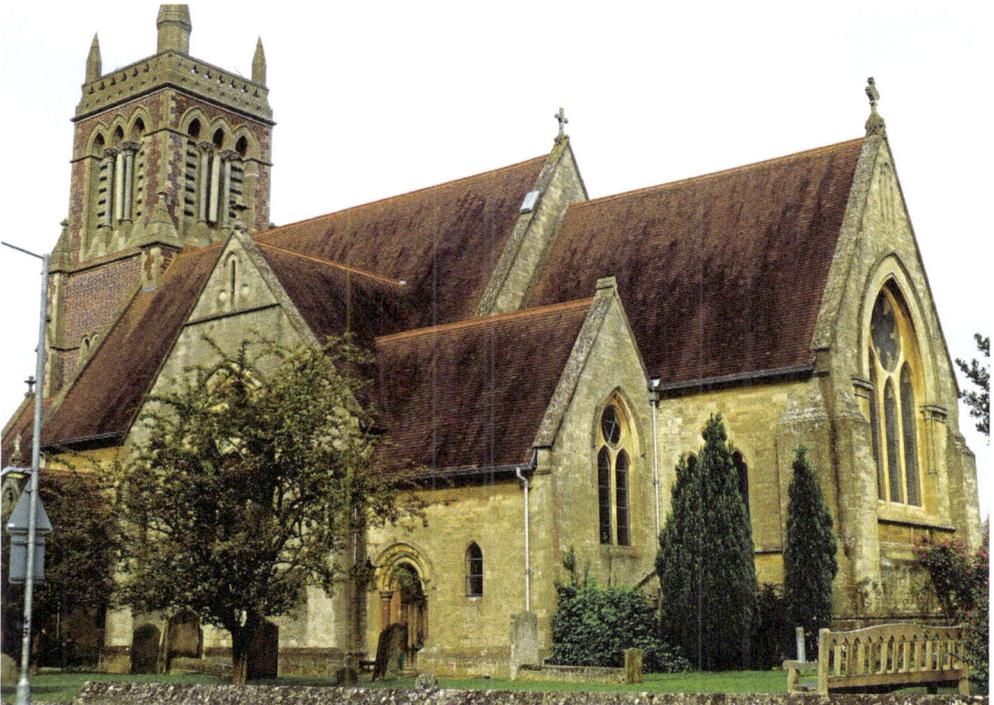

St Michael and St Mary Magdalene's Church.

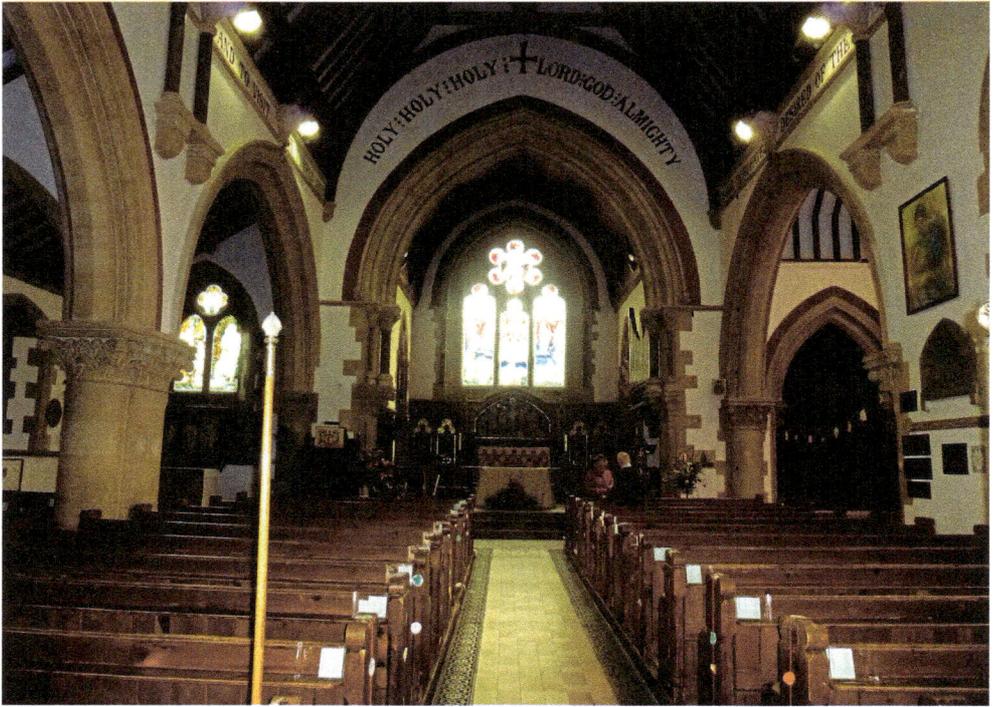

Interior of Easthampstead Church.

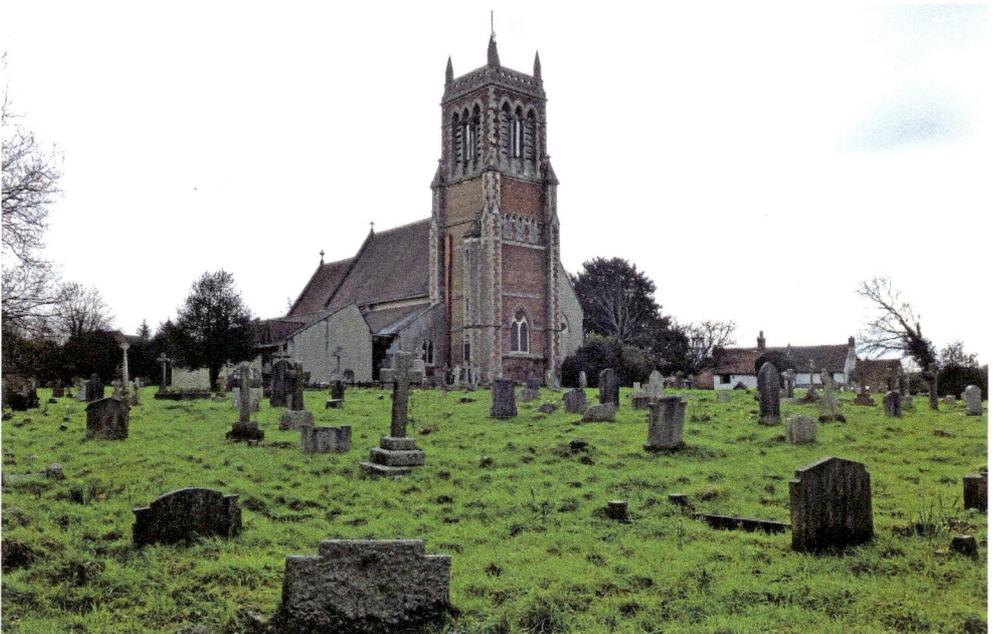

Easthampstead Church and graveyard.

DID YOU KNOW THAT…?

The almshouses and infirmary became the Union workhouse and Church Hill House was known as the Old Workhouse. With advent of the NHS, Church Hill House became a hospital for the 'Care of Mentally Deficient Men and Boys'. Later more appropriate accommodation was found and Church Hill House was replaced with new housing.

War by keeping a low profile and, after the Restoration, Charles II rewarded him by absolving him from the responsibility of maintaining deer in the park for the sovereign's pleasure.

He died in 1678 and his son, William Trumbull III, took over. However, he did not spend a great deal of time in Easthampstead as he travelled widely on behalf of the king. At one time he worked with Samuel Pepys who was not very impressed with him. Pepys described him as 'a man of the meanest mind as to courage that ever was born.' In spite of Pepys' opinion, Trumbull was knighted by James II in 1684. After he retired from public life he met Alexander Pope, whose family had moved to Binfield in 1700 when Pope was eleven. Despite the difference in their ages, the seventy-year-old William Trumbull befriended the child and became his mentor.

He was the last of the male heirs and produced only one child, a daughter. She had one daughter, Mary, who married Arthur Hill, the 2nd Marquis of Downshire. Because her inheritance passed to her husband the Downshires became Lords of the Manor of Easthampstead. The 4th Marquis succeeded his father in 1845.

In 1863 the Oxford diocese was created and Easthampstead became part of this. The new diocese was not impressed with the state of the medieval Easthampstead Church. Over the years, it had not been maintained well and it was eventually decided to demolish it and build a new one at a cost of £3,000. The money was provided by the Lord of the Manor and his wife, Caroline. The foundation stone was laid in 1865 and the church was rededicated in 1867. The current Rector, who had been inducted in 1860, remained in his post until he retired in 1883. Christ Church, Oxford, is the patron of Easthampstead Church and, when, in 1988, a new vicar was inducted, one of the patrons from Christ Church who attended was John Fenton, a noted theologian and a descendant of Elijah Fenton who had tutored the young William Trumbull in the eighteenth century.

The mansion that had replaced the original hunting lodge was demolished in 1860 and was replaced with Easthampstead Park Mansion which still survives.[3] The stable block is the only part of the old building that remains. The new building was recently

DID YOU KNOW THAT…?

The pulpit in St Michael's Church in Easthampstead is dated 1631 although the actual building is much later.

described by the Department of Education as a 'building of historical and architectural interest, in Jacobean style with curved gables pieced stone parapet and stone frontispiece of naïve classicism.' Below the staircase, a huge stained-glass window commemorates the Downshire dynasty. To house their servants, several cottages were built on the estate at the same time.

In 1847 the 4th Marquis of Downshire inherited the title.[4] To celebrate this, he proposed to present a clock to be installed in the church tower. The branches of an ancient yew tree encroached on the church gate. One Sunday, on his way to church, the marquis's hat was removed by one of the branches. Incensed, the marquis demanded that the offending branch be cut off. When the rector and churchwardens refused his request, he withdrew his offer of the clock and, instead, in 1847 he presented it to the almshouses opposite.

The 5th Marquis of Downshire, who died young in 1874, is commemorated by the eastern window in the church. This was designed by the Pre-Raphaelite artist, Sir Edward Burne-Jones, and made in William Morris' studio. It depicted the Last Judgement. His son, the 6th Marquis, lived most of his life on the estate and made an interesting addition to it. This was a miniature railway on which the family and their servants could travel the short distance to church every Sunday. In 1790 some almshouses were erected in Easthampstead and in 1826 these became a workhouse which was enlarged in 1889.

During the Second World War, the High Master of St Paul's School in Hammersmith visited the mansion to see if it would be a suitable building for the evacuation of the boys from his school. Lady Downshire was not sure. 'We only have 95 rooms,' she told him.

He obviously considered that would be sufficient and the boys descended on Easthampstead. At first they were housed with local families and lessons were held in the mansion. Later, some houses were bought as hostels for them. The army had

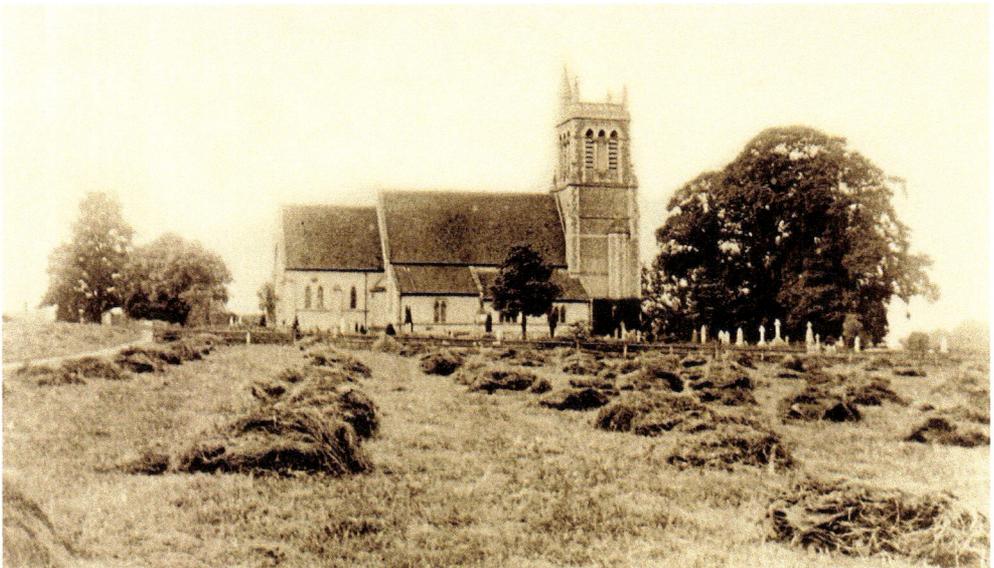

View of Easthampstead Church in 1890s. (Courtesy of Eileen Briggs)

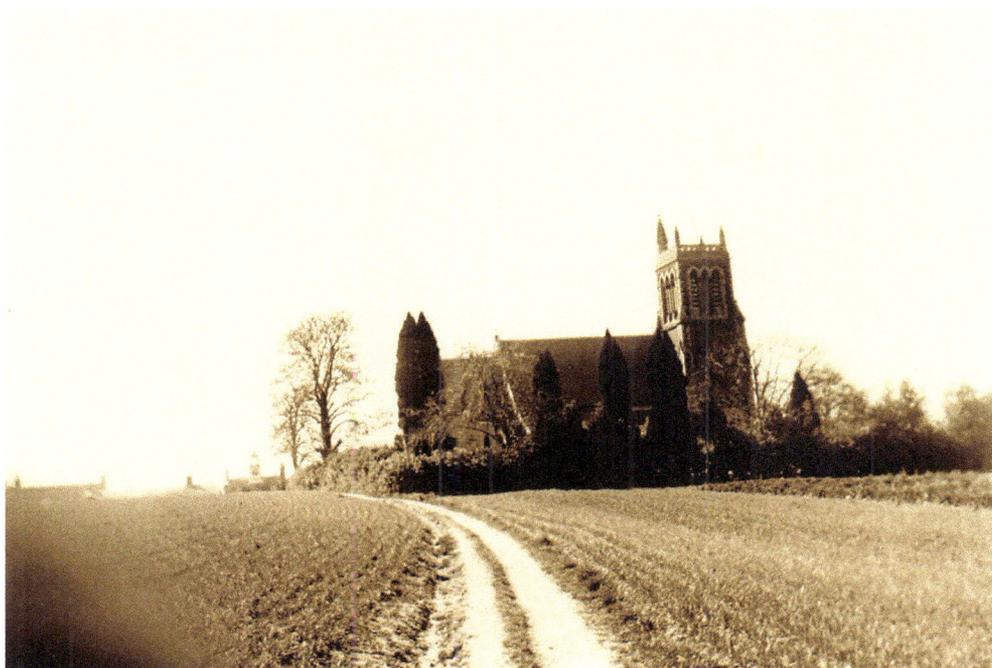

Footpath through cornfield to church. (Courtesy of Eileen Briggs)

The former cornfield, now housing estate. (Courtesy of Eileen Briggs)

The former cornfield, now a housing estate. (Courtesy of Eileen Briggs)

commandeered part of the park and a number of Nissen huts had been built. In 1941 German bombs fell on the main drive but fortunately there were no casualties.

At the end of the Second World War, the Downshires moved to Ireland. They sold the estate to Berkshire County Council and the centuries old tradition of 'Lords of the Manor' came to an end in this area.

DID YOU KNOW THAT...?

In the nineteenth century the public contributed to the building of Holy Trinity Church in Church Road and, on 26 February 1851, it was consecrated. In 1951 its spire was the highest point in the town. However, soon after this, new office blocks were built to challenge its record. Then in 1964 the impressive high-rise block of flats, Point Royal, was completed. With its seventeen storeys, it had no competition and is now the tallest building in the town.

4. Ranelagh School

Ranelagh School holds a unique position, not only in Bracknell but also in the history of education in England. It is possibly the first institution where two schools were constructed simultaneously for the education of both boys and girls – equality of the sexes was still over 200 years in the future. Under the laws of the land in the eighteenth century, a daughter could not inherit her father's wealth; on his death, it would automatically pass to her husband.

The first Earl of Ranelagh had one son and three daughters. One of the daughters, Frances, married the Earl of Coningsby. Lord Ranelagh thoroughly disapproved of his new son-in-law and decided to disinherit his daughter by founding a trust. He appointed seven trustees to run it. On 6 December 1709 he and his trustees signed the deed. The income from the trust was to be paid to the earl until his death. After he died, this money was to be used for 'maintaining and repairing for ever the two free Schools the one for teaching and instructing twenty poor boys and the other for the teaching and instructing twenty poor girles [sic] gratis, lately erected near Cranbourne in the Forest of Windsor'. An original letter from Lord Ranelagh, dated January 1710, was found in the school's archives. It speaks of payments to be made to certain persons in the Windsor area.

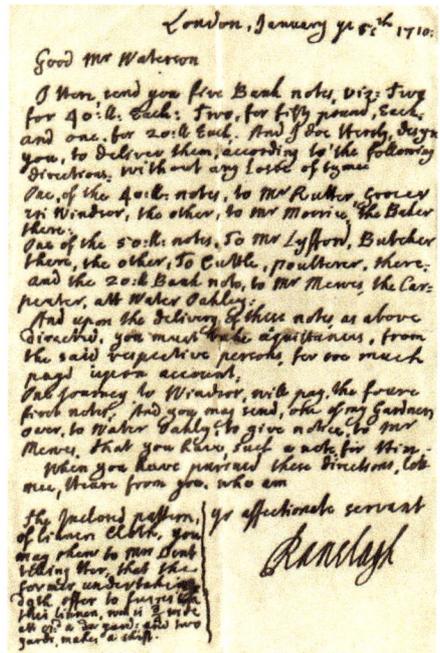

Letter from Lord Ranelagh. (Courtesy of Ranelagh School archives)

The school had been built during 1709 but it is not known when it received its first pupils. Lord Ranelagh died in 1712 and, until his death, he paid all the expenses of the school. In the deed he gave instructions for the running of the school. A Master was to be in charge of the boys and a Mistress was responsible for the girls. Both had to be English Protestants. The master had to be an ordained priest of the Church of England and would receive a salary of £30 a year; the mistress was paid £20. Both salaries would be 'free of all taxes and deductions'. Annual grants of £8 for fuel and £4 for a servant to clean the establishment were made. Each year four boys and four girls were to be bound as apprentices at the cost of £5 each. The rest of the money was used for repairs and to buy stationery and other necessities.

The earl also decided on the curriculum. Boys were to be taught 'Reading, Writing and Arithmetick' and the girls 'Reading, Writing, Spinning, Knitting, Sowing'. Religious instruction in accordance with the Church of England's teaching and knowledge of the catechism was compulsory. In the summer, the school day was from 7.00 a.m. until 5.00 p.m. with a midday break; the winter hours were from 8.00 a.m. until 4.00 p.m.. Parents were expected 'to send their children to Schoole Cleane, Washed and comb'd also to mend their Cloths '.

Each pupil was provided annually with a uniform. The boys wore a green jacket, corduroy breeches yellow stockings and a beaver hat. The girls had green dresses, cloaks and bonnets. The trust kept a record of expenses.

Green Yarn	£1 10s 6d
For makeing 20 coats	£1 1s 6d
For 20 pair of breeches	£2 10s

The first master was William Waterson, who was appointed by Lord Ranelagh himself. He held the office until his death fifty years later in 1759; his forceful personality, without doubt, left an indelible mark on the school. Elizabeth Dent was appointed as the first mistress but she died in 1722 and was succeeded by Elisabeth Morrison.

Because there were no specified holiday dates, there were frequent absences for various reasons. Continued absence sometimes resulted in expulsion as in the first case recorded in 1722. Mary Hester was 'turn'd out for neglecting the School'. In 1740, to discourage random absences, it was stipulated that children must attend school for 120 days during the year. Little notice was taken of the new rule and in 1759 Richard Steer was 'expell'd the School having been absent 207 school days during the last twelvemonth'. Absences continued and, in 1769, the number of days children were expected to attend was decreased to 100. However, it was not until 1820 when definite holiday dates were fixed that things improved. From then on, there was no school during August, two weeks' vacation at Christmas and one week at Easter.

The trustees met once a year and celebrated the occasion with an anniversary dinner. They kept detailed minutes of their meetings and of the progress of the school, reported to them by those who had been appointed as overseers. Also recorded were any actions the trustees were required to make. In 1824 the Revd David Edwards was appointed as master. He resigned suddenly in November 1837 after it was alleged that he had 'ill treated Mrs Edwards and beaten her so that she is confined to her bed'. He had apparently

also threatened to murder her. His resignation left a vacancy that was not filled until the following March so the boys had an unexpected holiday. They had another unexpected vacation in 1873 when it was discovered that the master, 'Mr Clements, has again absented himself from his duties from 28th January last without permission and nothing has been heard of him since'. John Middlemist was appointed master later in 1873.

Two of the mistresses were also dismissed but no blame could be attached to either of them. Miss Elizabeth Milton was appointed in 1803 but in 1854 the trustees recorded that 'it appears that Miss Milton, the present Mistress being upwards of 80, is incapacitated from discharging the duties of her office.' The other recorded dismissal of a mistress was in January 1870 when Miss Lusignan was given three months' notice to leave her position. She had committed the crime of getting married and had become Mrs Baxter.

The original school catered for twenty boys and twenty girls but the numbers gradually increased and, towards the end of the nineteenth century, it was decided to expand and reorganise the school. As the trust was becoming short of money, it applied for and received a government grant to enable a new school to be built. This provided primary education for both boys and girls and was known as Cranbourne Ranelagh School. Much of the income came from public funds but the trust also provided some grants.

As the new century dawned, the trustees became convinced that secondary rather than primary education was needed in the area. In 1904 The Board of Education granted the trust permission to found a Church of England grammar school. Six acres of land were bought in Bracknell and a new school was built. In 1908 Ranelagh School opened as a grammar school on its present site. A prospectus was drawn up by the governors. Several of these were from the 'Ranelagh Foundation' as the original trust was now known. However, as the school was not mainly funded by the government, other governors from the community were appointed. It was eventually decided that it was no longer necessary for the head of the school to be a clergyman and Mr Ernest Cleave was appointed as the first headmaster.

The school would be run 'on modern lines and at moderate cost'. Pupils could be admitted to the school at eight and could stay until they were eighteen. Those under ten were charged £2 13s 4d per term and for those over ten, the fee was three guineas.[1] For those who wished to learn shorthand or a musical instrument there was an extra charge. Space was available for 'limited number of pupils' to have a midday lunch at the cost of two guineas per term. There was also an extra charge for those who wished to take part in games. A four-year course was available to provide 'adequate preparation for entrance to the various professions, or for business'. In addition to the core subjects, French and German were offered and there was 'manual instruction, sewing and drill'.

Mr Ernest Cleave became greatly respected and was known to be strict but fair. He was ably supported by his wife who provided the lunches and even taught wood carving. More teachers were appointed. The oldest member of staff was Sgt-Maj. Parsons, the caretaker and drill instructor. His son, Charles, was in the first intake of pupils who entered the school on 1 September 1908. There were twenty boys and thirteen girls. One of the girls was Alice Carter who, in 1959, attended the 250th anniversary of the founding of the school. Some of the pupils were local but others came from nearby towns and villages and travelled by train. The Railway Company gave them a discount on 3rd class season tickets. By the end of the first term, the number of pupils had increased to fifty-three: thirty girls and twenty-three boys.

The school day began with assembly in the hall and, following this, the pupils went to their classrooms where most of the classes were of mixed ages. This must have been very difficult as the older ones were held back and the younger ones did not find it easy to keep up. Most subjects on the curriculum were taught by non-specialist teachers.

Part-time staff taught art, woodwork, music and housewifery. The first English specialist, Miss Gahan, was not appointed until 1919; in 1910, Her Majesty's Inspectors had noted that 'the production of certain sounds, especially some vowel sounds is often not good'. In the margin of the report Mr Cleave had written 'Berkshire', no doubt referring to the distinctive Berkshire accent of most of the pupils. 'Setting' for mathematics had been introduced earlier but some pupils were very weak in this subject.[2] It was not until 1922 that Mr Strawson, a mathematics specialist, arrived.

All pupils received homework but one class considered that one teacher, Mr Whittacker, gave them too much to do. They therefore sent him a round robin to this effect. Unfortunately they had not checked their spelling before they sent it to him and it contained two spelling mistakes. Consequently, the petition was ignored and the class was told to write out the misspelt words – 1,000 times each!

After Sgt Parsons retired, Physical Education and games were taught by those with no specialist training. In 1910 the inspectors considered that the boys 'were very slow in coming back to attention' but they complimented the girls on their drill. In the winter, the boys played football and the girls hockey while the summer games were cricket and tennis. Both boys and girls played cricket. It was not until 1957 that Mr Cross, a trained Physical Education teacher, was appointed.

The years during the First World War had an impact on the school as the male staff went to fight and the majority of the staff were female. During the war refugees arrived in Bracknell and Belgian, Russian and French pupils joined the school. As a diplomatic gesture, the school was taught the national anthems of the three countries. One pupil had vivid memories of lunches at this time. Rationing had been introduced and pupils had to bring coupons to 'pay' for their meal. She remembers that Mrs Cleave, the headmaster's wife, became very angry if anyone forgot these valuable pieces of paper. When the war ended in 1918, a special assembly was held at which the school was informed that the Armistice had been signed. Mr Cleave then read out the names of the fifteen ex-pupils of the school who had given their lives for their country.

The staff shortage continued even after the war. In 1921 there were only six full-time teachers and only one of these was male. By this time pupil numbers had increased to 138. However, when Her Majesty's inspectors again visited the school, they were impressed with the progress that had been made since it opened. They felt that the pupils were working hard and were well behaved.

Under Mr Cleave and his loyal and devoted staff, the school flourished and forged a name for itself in the area. There were two classes each year from the eleven-year-olds to the fifth years who were taking School Certificate.[3] Some pupils left after this to work in banks or local businesses but some stayed on into the sixth form; an increasing number went to university.

Extracurricular activities abounded: in 1920 a school magazine was started; debates were held on topical subjects; sports fixtures featured regularly. A tradition that still continues is the annual school play. The first one in 1922 was Shakespeare's *Twelfth Night*.

Over the years the choice of plays ranged from Shakespeare and the Classics to more modern plays. The 1930s also saw some school trips across the Channel to France.

Mr Cleave retired in 1934 and Mr James Bury, who had taught in the school since 1919, was appointed as the new headmaster. Under him, the school retained its excellent reputation in the area but war was looming and things were about to change. Contingency measures were put in place; trenches were dug in the school grounds, fire extinguishers, sand bags and first aid boxes were located and the school was identified as a centre for the distribution of evacuees.

These arrived in September 1939. As well as the thirty individuals, three schools were also evacuated to Bracknell and Ranelagh was reorganised to cater for them. The Ranelagh pupils and the individual evacuees had lessons in the morning while, during the rest of the day, the evacuated schools made use of the facilities. As in the First World War, some of the male staff were eventually called up so there were frequent staff changes.

There was a more radical change towards the end of the Second World War in 1944 when the new Education Act was passed and an eleven-plus test was introduced for entrance to a grammar school. The ramifications of the Act affected Ranelagh which wished to retain its unique identity. It took several years before the situation was resolved satisfactorily and before that, there had been another major change. In 1949 Bracknell was designated a new town. The population grew and three more secondary schools were built to cater for the increasing population.

Ranelagh School, 2016.

DID YOU KNOW THAT…?

On 27 May 1863 the first female patient was admitted to Broadmoor Criminal Lunatic Asylum near Bracknell. The first male patients arrived on 27 February 1864. By 1868 there were five blocks for men and one for women. Today it is a high security psychiatric hospital for men and women. In 1952, an alarm system, based on the Second World War air sirens, was set up. When an alarm is sounded signalling the escape of a dangerous criminal, pupils at Ranelagh School are not allowed to leave the premises until the 'all-clear' is sounded.

In 1951 the examination system changed. School Certificate was replaced with GCE (General Certificate of Education). An 'Ordinary Level' (O-Level) examination of a number of subjects was taken by those in the fifth year while those staying on into the sixth form took A-Level (Advanced Level) specialising in only three subjects.

The following year, the first inspectors since 1930 arrived at Ranelagh. They found that the teaching was of a 'satisfactory competence and no weak place'. However, the facilities would have to be considerably improved. The school was still waiting for the Local Education Authority to decide on its future. It was not until the following year that Ranelagh eventually became a voluntary aided school. Mr Bury retired the same year and on 24 April 1953 Mr Donovan Martin was appointed as the new headmaster. Because of the Second World War, the building of the new town and the 1944 Education Act, the school had not been maintained as well as it had been in the past. Mr Martin set to work to remedy this.

More classrooms, some laboratories and a new hall were built. Later, the playing fields were improved and a new cricket pavilion built. By September 1964, the buildings were completed and Ranelagh took its place as a two-form entry grammar school with 400 pupils. A month later, a new Labour government came to power and decided on the 'reorganisation of secondary education on comprehensive lines'.

It took a while for the plans to be implemented and for the rest of the decade under Mr Martin's headship, Ranelagh maintained its high academic standard. Most pupils continued into the sixth form and many went to university.

On 4 June 1959 the school celebrated its 250th anniversary. Using early records of the uniforms, Mrs Fahy, a mistress at the school, dressed two small dolls in the original costumes. She was aided in this by ninety-seven-year-old Walter Grey who had attended the school in the 1870s. He remembered wearing the uniform on special occasions. When the school moved to a new venue in 1879, this custom was discontinued. One of the visitors to Ranelagh for the 250th anniversary was Miss Alice Carter who had been one of the first pupils to register when the new school had been opened on its present site in 1908.

To celebrate the occasion, Mrs Martin, the headmaster's wife, had made a most impressive cake. When the whole school had assembled on the lawn in brilliant sunshine, Miss Carter cut the cake. As well as the guests and staff, each pupil received a slice; another slice of it resides, carefully wrapped, in the school's archives.

Sadly, Mr Martin died in June 1970 and the new headmaster, Mr Richard Allen, was appointed in December of that year. However, he did not start at the school until April 1971. He steered the school towards changing its status from Grammar to Comprehensive. This took some time and it was not until 1981 that the first comprehensive entry took place. In 1988 GCSE (General Certificate of Education) replaced O-Level; Ranelagh maintained its high standard and became recognised as one of the most successful comprehensive schools in the area.

Mr Allen retired in April 1993 and the same month Mrs Kathryn Winrow was appointed as Ranelagh's first female head. Under her leadership, the school continued to flourish and kept up many of its original traditions. She retired in 2014 and, in January 2015, Mrs Beverley Stevens succeeded her.

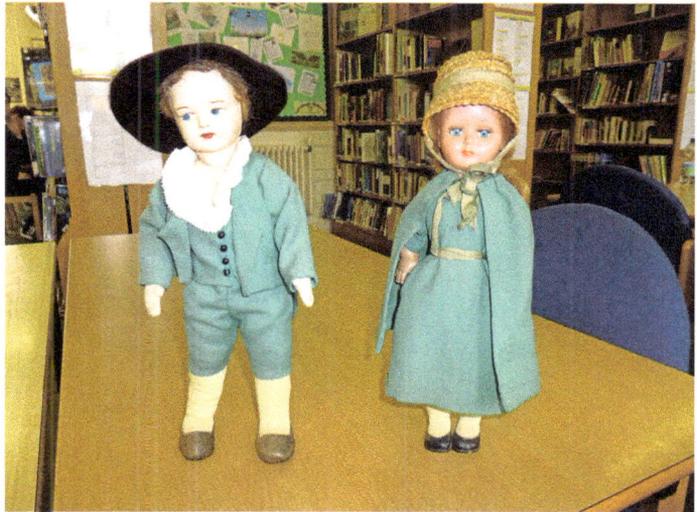

Dolls dressed in the original uniform. (Courtesy of Ranelagh School)

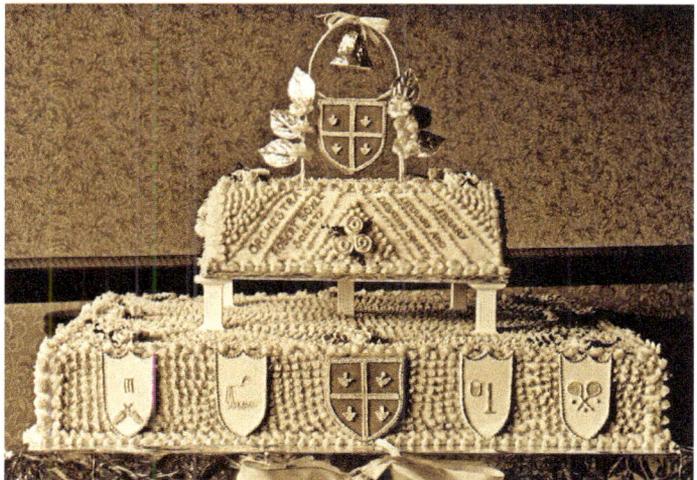

250th anniversary cake. (Ranelagh School Archives)

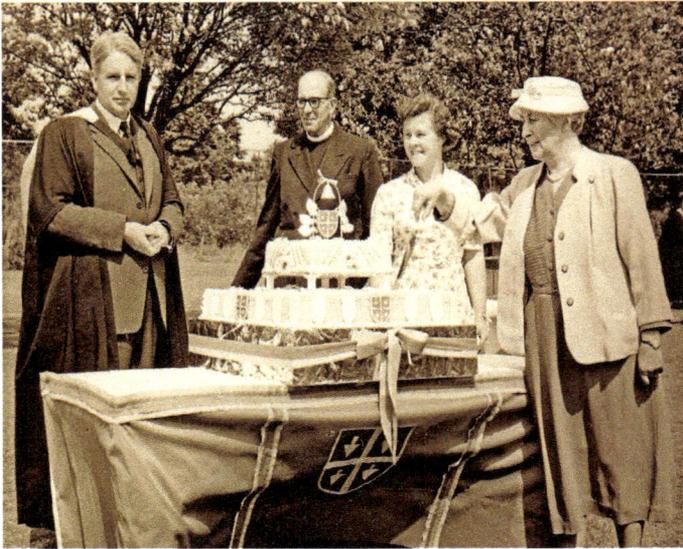

Alice Carter cutting the cake with VIPs watching. (Ranelagh School archives)

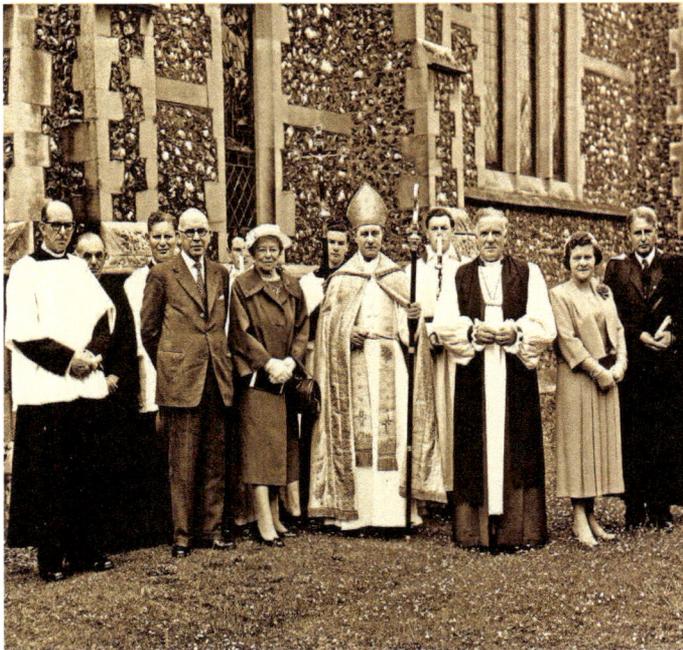

Guests at the anniversary outside Holy Trinity Church. (Ranelagh School archives)

DID YOU KNOW THAT...?

Lord Ranelagh was very friendly with Queen Anne. He was the paymaster during the Duke of Marlborough's European campaigns.

5. Bracknell's Ghosts

According to local residents, Bracknell has had a number of ghostly visitations. One of the earliest can occasionally be heard on still nights at Caesar's Camp. Originally an Iron Age fort, this was abandoned when the Romans invaded in AD 43 but their soldiers can still occasionally be heard marching around the area.

An unusual haunting tale dates from the seventeenth century. There was a mill standing beside the pond which still bears the name Mill Pond. The farmer who lived there was very miserly and one evening, he refused to give food to a poor man who came begging at his door. The following morning the beggar was found frozen to death on the doorstep. That was not the end of the matter because from then on everything went wrong for the farmer. His cattle died, his land was flooded and his crops failed. Eventually he became so poor that he and his family left the mill.

Because of its reputation, the local people shunned the mill and it became a ruin. Tradition says that eventually some villagers set fire to the remains of the old building to rid it of its unlucky reputation. Later, Mill House was built on the site.

Mill Pond, 1950. (Courtesy of Eileen Briggs)

Several later occurrences took place in South Hill Park. The last owner of this estate was Major Rickman who had inherited it from his aunt, Lady Haversham. It was not a happy bequest as, with the vast estate, the Major also inherited crippling debts which he was unable to pay off. This obviously preyed on his mind and he became very depressed. Eventually, unable to bear the pressure any longer, he sat down in his gun-room, put a gun to his head and took his own life.

He did not desert his one time home however; until recently, footsteps could still sometimes be heard in the area where the grizzly deed took place. The Major has also been seen walking on his veranda and staring sadly out at his heavily mortgaged land. Since the Atrium Bar has now replaced the Major's veranda, there have been no more sightings. Perhaps the gentleman no longer wishes to inject a sad note into the happy chattering of the customers.

Elsewhere in the building, supernatural events still take place. A Victorian gentleman, dressed in top hat and tails, has been seen nonchalantly walking along the corridor towards the Studio Theatre while inside the room, apparitions of ladies of the same period occasionally appear and doors are opened without the help of any human agency.

The adjacent building, the Wilde Theatre, has also had its share of supernatural activity. The Lady in Red often appears on a Saturday night. Dressed in 1940s fashion, she wears a red dress with a wide black belt around her waist. One night she startled a stage technician who was walking up the stairs towards the balcony. At the top of the stairs, the Lady in Red stared down at her. The apparition vanished before she could be studied in more detail.

Unexplained noises have also been heard in the theatre itself. The doors, on all three levels, often slam shut simultaneously. Another eerie incident took place late one evening. Two technicians were preparing for the next day's show in one of the green rooms.[1] They had forgotten to switch off the stage microphone which pipes the voices from the stage so that the actors can hear their cues. Suddenly they heard footsteps on the stage. Knowing that there should be no one else in the building, they rushed into the theatre but it was empty. Whose footsteps had they heard?

Kell's House in Church Road was demolished in the twentieth century to make way for a dual carriageway. That must have been very sad for the monk who had reputedly haunted the house. Although there was never an apparition, those who lived there were convinced it was haunted. Nothing was ever seen, but occupants heard the swishing of draperies as if someone had brushed past them. Why it should be a monk rather than a lady in a flowing gown is not clear.

Other sounds were also heard on the stairway leading to the rooms above a chemist's shop at the top of the High Street. Often late at night dental mechanics would be working there. They were often disturbed after midnight by footsteps stamping up the stairs towards them but there was never evidence of any human presence.

Another unusual 'haunting' occurred in a local shop while some of the staff were having a tea break. They watched a little man loaded with parcels crossing the car park. He was wearing a smock like those worn by farmers at the beginning of the twentieth century. At the time this did not apparently appear unusual and one of them opened the door to let him in. Then, to their astonishment, he ignored the door and disappeared through the wall. Shaken, they wondered if the police could throw some light on the mystery. The Sergeant they spoke to did not seem surprised at their story.

'Oh he's appeared again, has he?' he sighed, opening a cupboard door and pulling out an old map. He spread it out on the counter. 'Look that's where the car park is now and this lane is where he was walking. It goes right through the car park and continues through the wall where he disappeared.'

His matter-of-fact attitude rather deflated his listeners but the story had not ended. A few days later the gentleman appeared again, this time in the stock room. Presumably he had come to unpack his parcels. He became a familiar figure and it always became very cold just before he appeared. On one occasion he was even seen in the window of the shop. While the staff became used to him, they were not amused when items started to disappear. When the missing items were replaced, the original things reappeared! Their visitor obviously had a sense of humour.

The atmosphere in the shop became so cold before his appearances that customers complained. It was eventually decided that it was time to call in a priest to exorcise the shop's unwelcome visitor. This was successful and, as the shop was no longer haunted, the temperature returned to normal.

As Bracknell is situated near Ascot, it is not surprising that horses feature in supernatural tales of the area. Ghostly galloping has often been heard in Kennel Lane where stables had been converted into a cottage. Strange sounds were sometimes heard in the bedrooms which would have originally been the hayloft.

Another ghostly horse could also be heard galloping along Ralphs Ride. At one time, known as Ralph, he was used to frighten misbehaving children. The threat, 'Ralph will get you,' usually made them behave. Horses also made their invisible mark elsewhere. A resident in a house on what had been known as the 'Links' was startled one evening to hear horses' hooves pounding past her window and making the house shake. Heart beating, she ventured into the garden but could find no sign of the intruder. She assumed that, once again, some local lads had let loose a pony and expected to find hoof marks all over her lawn. The following day, however, she found no marks at all on her pristine grass. When she mentioned her nocturnal visitor to a friend, the lady immediately replied, 'Oh that would have been Dick Turpin.'

Dick Turpin had, of course, been a notorious highwayman who had terrified Bracknell residents so perhaps it was not surprising that he should return to the scene of his crimes. Having ridden down the Links, he would have ended in Ralphs Ride so perhaps 'Ralph' was Dick Turpin.

Another 'horse sighting' was remembered as a childhood incident by Frank Jones. In the 1920s he and his sister, Phyllis, were sent one evening to buy something from a shop in Binfield Road. The children carried a am jar into which a candle had been inserted to give them some light. They walked along the lane beside the Bull Inn in the High Street and crossed over a stream that led to a dark murky pond which, at one time, had probably been used by cattle as a watering hole.

'Suddenly,' Frank recalled, 'as we crossed the stream, we saw a black horse being led out of the pond by a young man who was having difficulty in controlling it. The animal was very large and obviously well-cared for. It was of the type usually used for ploughing but on its head was some chain armour. The man also wore armour but I did not see any weapon. We were so startled we dropped the jam jar and fled. Fortunately the candle went out so we did not cause a fire! When we returned the next day, we found no hoof prints or any evidence of the nocturnal visitor.'

There is no record of any other sightings of this particular horse and rider but there were many stories of horse-drawn carriages being heard in Kennel Lane. These would draw to a halt. Had they perhaps been stopped by Dick Turpin or another highwayman who frequented the area? While no carriages were ever seen, the nearby school was visited in the early 1990s by a beautiful Lady in Grey. Her golden hair was held in place by a riding hat and she wore an elegant grey riding habit with the long skirt trailing over long buttoned boots. She appeared to be looking for something. Had she perhaps lost her horse? She appeared several times to those who worked at the school but gradually her sightings became less distinct until eventually she was seen no more.

Ralph's Ride had other nocturnal visitors beside horses. During the restructuring of Bracknell, houses in the road were demolished as soon as they became vacant. One night two workmen decided to sleep in one of the empty houses. They had a dog for company. They rolled out their sleeping bags and were preparing for the night when they heard footsteps in the next room. Expecting prowlers on the lookout for rich pickings, one of them went to investigate but there was no one there so he returned. The footsteps were heard again and they sent the dog into the room. Growling, it hurtled out of the house and was never seen again.

Shaken, the men checked all the rooms but could find nothing that would account for the dog's behaviour. When they returned to their 'bedroom', they noticed that an old mangle, standing in the corner of the room, was starting to move. As they watched in horror, it hurtled towards the opposite wall which it hit with a resounding crash. Without waiting for anything else to happen, the two men hastily retreated to find a venue that was devoid of footsteps or moving mangles!

Another ghostly visitation took place in Lily Hill House during the 1980s. A resident, who was working there, was disturbed by the sound of doors opening and shutting. Knowing that he was alone in the house, he was puzzled and went to investigate but found no one so he went back to work. The banging of doors continued and, irritated by the interruption to his work, he hurriedly left. When he repeated his experience to a friend, she looked surprised.

'Is that still happening?' she asked. 'I worked there as a maid fifty years ago and we had the same problem. We'd go into one of the bedrooms to clean and although we left the door open, it closed behind us. But it was worse than that. Sometimes the door was locked and we couldn't get out. Fortunately my father also worked in the house and we were able to call him. He found a ladder and propped it against the window so we could climb out. It was very weird but we got used to it.'

Her companion shook his head. 'I don't think I'd get used to it. I found it very annoying when I was trying to concentrate.'

Another 'sound haunting' was rather different. An old house in Broad Lane had obviously been a happy house filled with children whose ghosts were often heard by later residents, running up and down the stairs. Investigations again found no evidence of any human children. With the future restructuring of Bracknell, will the ghosts all disappear?

A haunted chemist shop in High Street. (Courtesy of Eileen Briggs)

The Fielden House replaced the chemist – 1990s. (Courtesy of Eileen Briggs)

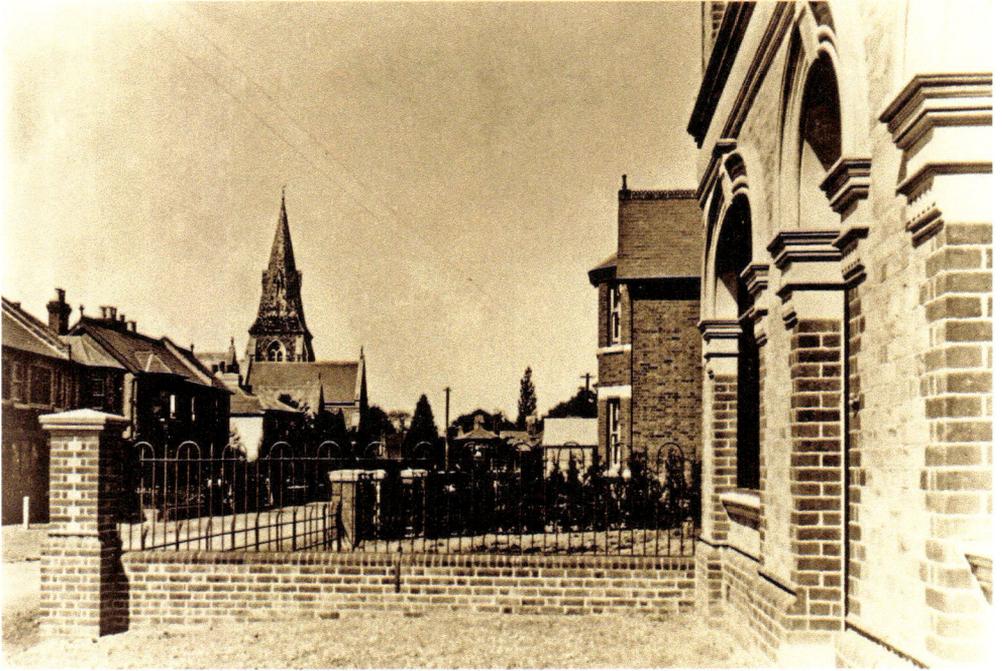

Church Road showing Kell's House on the right. (Courtesy of Eileen Briggs)

6. South Hill Park

Today South Hill Park is a Grade II-listed building set in landscaped gardens and parkland. However, the area was originally part of Windsor forest. It is possible that, during the early part of the seventeenth century, it was illegally enclosed. A house was presumably built later as a title deed of 1683 mentions a 'Mansion house known by the name of South Hill' being leased to William Samrooth by Ann Bagley.

Little is known of the intervening years until 1750 when Bruce Fisher bought the house renaming it Fisher's Lodge. He was granted planning permission to enlarge it and used stuccoed brick. Ten years later, William Watts, a retired official from the Bengal government, acquired the estate. By the end of his career, he was very wealthy and decided to implement some changes. He remodelled the house and turned it into a classical villa. The farm buildings were moved further away. He also decided to enlarge the estate. To do this, he enclosed 30 acres of common land increasing the estate to 800 acres. To pay for the extra land, he built a number of almshouses opposite the church to provide for the poor. When he died, he left an annual endowment of £320 which was to be used to help the poor in perpetuity. Known as Watt's Charity, this still exists but today it is used in small donations to benefit the community.

The next two owners of the estate, the Honourable Henry Bouverie and in 1786, Sir Stephen Lushington, have passed into obscurity but in 1800 the estate was bought by the colourful George Canning, who later became both Chancellor of the Exchequer and Prime Minister.

In 1801, Sir John Sloane was commissioned by Canning to design some alterations to his newly acquired house. A conservatory, overlooking the garden, was built on the south elevation and alterations were carried out on the rest of the original building. Some of Sloane's work has been incorporated into the present building.

Canning spent much of his time in his renovated mansion and Sir William Pitt, the Prime Minister, was one of his visitors. Canning left the park in 1806 and sold it in 1808. The Earls of Limerick acquired it but by 1847 the owner was Sir James Matheson. In 1853 he sold it to Sir William Hayter, a politician. Sadly, he suffered from depression and in 1878 he was discovered, drowned, in one of the lakes. The estate then passed to his son, Sir Arthur Hayter.

Sometime during 1890, there appears to have been a fire in the nursery at the South Hill Park Mansion. There is no record of the date but charred remains, including human bones, were found. Although these were not formally identified, it seems possible that they were the children of Sir Arthur and Lady Haversham. Later visitors to the present Studio Theatre, the site of the original nursery, have sometimes been aware of ghostly footsteps on the stairs. Perhaps the servants were still trying desperately to rescue the

children. It was not surprising that, after the fire, Sir Arthur decided on a major rebuilding of the mansion.

In 1881 he commissioned the architect, Temple Moore, to remodel the house at a cost of £17,700. Bath stone and bricks from the local brick works were used to add an extension to the east wing. The Haversham coat of arms was carved over the main door. The gardens near the house were also landscaped and terraced in 1893. The same year Prime Minister Gladstone visited and planted a Holm Oak tree to the north-east of South Lake. At the time there were four lakes but only two have survived although the oak tree can still be seen. In 1897 a front was added to the conservatory and, in 1898, a billiard room bay appeared. The 1883 Kelly's Directory described the house as 'a compact residence of brick faced with cement, standing in a park of 800 acres in which there are four lakes; the private gardens are very beautiful being laid out in terraces'.[1]

During the First World War, the Havershams allowed South Hill Park to be used as a collection centre for warm clothing which was sent to the troops in France. Villagers from the surrounding area brought a variety of woollen garments to the mansion and Lady Haversham and her helpers sorted and dispatched them. Arthur Hayter died in 1917 but his wife survived for several years. When she died in 1929, the estate was inherited by her nephew, Major Rickman. He was the last individual to own the estate. Unfortunately, as well as the estate, he also inherited crippling debts. He became very depressed and in May 1940 he shot himself in the gun room of the mansion.

Also in 1940 the Royal Sea Bathing Hospital was evacuated to the park from Margate. This had been founded in 1791 by Dr John Coakley Lettsom. His aim was to use sea water to cure tuberculosis. At first this could only take place during the summer but later he installed sea water baths inside the building so the treatment could be used throughout the year. In the twentieth century orthopaedics were also treated. The children from the hospital arrived at the park in May and the adults in June. The lakes in the park were obviously freshwater so one wonders how they managed to produce sea water when the park was situated many miles from the coast. Therapeutic treatments were, nevertheless, carried out until 1945 when the hospital returned to Margate. It continued to function until the mid-1990s when it closed and the building was converted into luxury flats.

South Hill Park was sold in 1946 and the new owner, Joseph Horn, also planned to convert the building into flats. However, this was not successful and in 1952 the park was sold to the BBC who used it for offices and recording studios.

Meanwhile, important events were happening nearby. In 1949 Bracknell had been designated a new town. During the following decade, old buildings were demolished and replaced by new ones. In 1962 Bracknell Development Corporation acquired South Hill Park but it was not until 1970 that it was decided to convert the site into an Arts Centre. This involved a great deal of renovation and eventually the building was officially opened in October 1973. It offered a variety of courses and activities. The following year the Terrace Bar was opened and, by the end of the 1980s, there had been more additions comprising Dance Studios, a bar extension and an Art Gallery. This provided for many contemporary fine art and craft exhibitions.

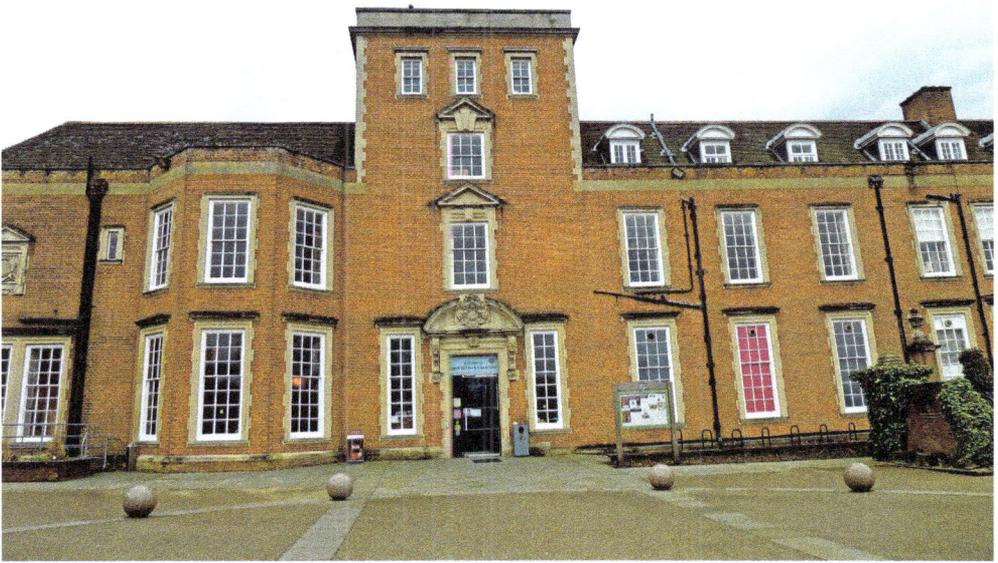

South Hill Park.

The house was demolished in 1966. (Courtesy of Eileen Briggs)

An office was built on the same site. (Courtesy of Eileen Briggs)

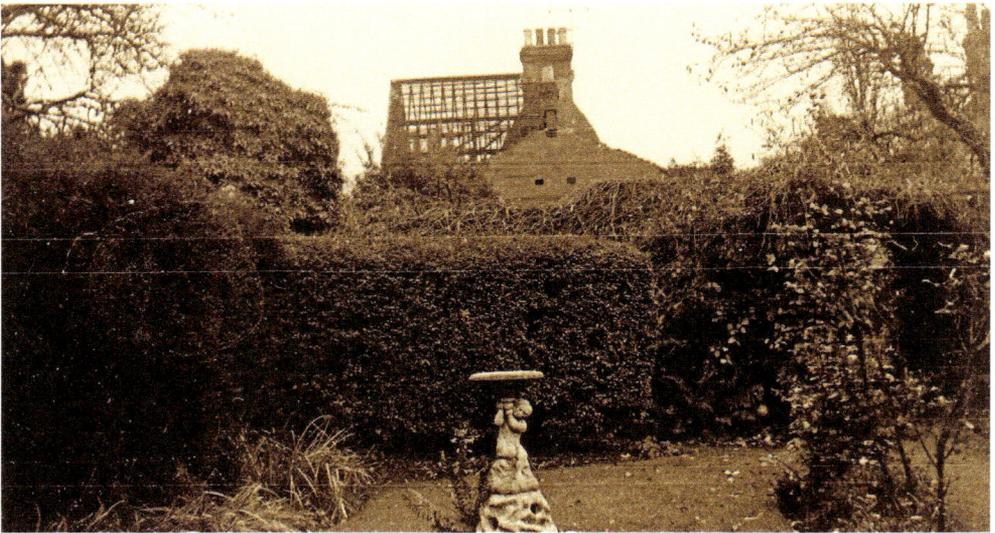

Another house demolished. (Courtesy of Eileen Briggs)

DID YOU KNOW THAT...?

Because there were no fridges in the nineteenth century, food had to be kept cool or it would go bad. South Hill Park was one of the houses to own an icehouse. Set underground in the park, food could be kept fresh for some time.

The Wilde Theatre

In November 1982 work started on a theatre next to the main building. The earth was first turned by Sir Henry Lushington whose ancestor had once owned the park. On 23 April 1983, Sir Michael Tippett laid the foundation stone while 'The Wolf Trapp Fanfare', which he had composed, was played by a group of musicians perched precariously on the scaffolding above. The architect of the new building was Alex Burrough; he designed the theatre with Shakespeare's courtyard theatre in mind. To ascertain the accuracy of the acoustics a 'testing' was arranged for March 1984. The 400 guests listened to a variety of sounds from different parts of the auditorium. The following month, the theatre opened its doors to an audience who watched the first performance. This was Oscar Wilde's *The Importance of Being Earnest*. Wilde had been a prisoner in the newly built Reading Gaol from where he wrote his famous *Ballad of Reading Gaol*. Perhaps this influenced the choice of play and also the name of the new theatre, The Wilde Theatre. The building was officially opened by Princess Anne on 15 May 1984.

The latest addition to the theatre was opened on Tuesday 10 February 2015. The Wild Upstairs replaced the original bar which was described as 'a cold, lifeless room with no personality.' The supermarket, Waitrose, had donated £10,000 towards transforming the area into 'a rich, warm and full of life room with a theatrical feel to it'. Tina Warns

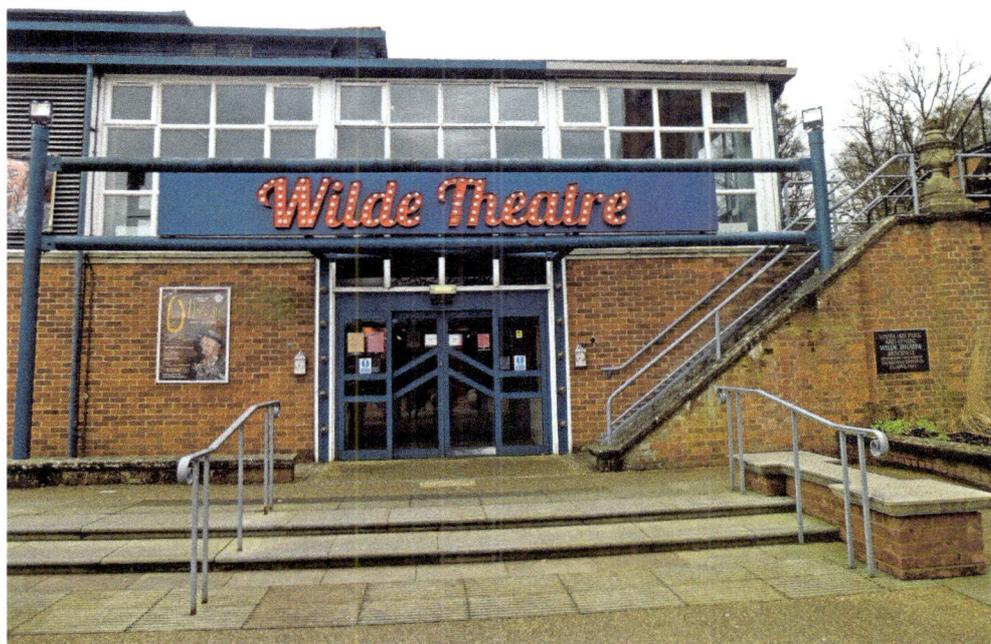

The Wilde Theatre.

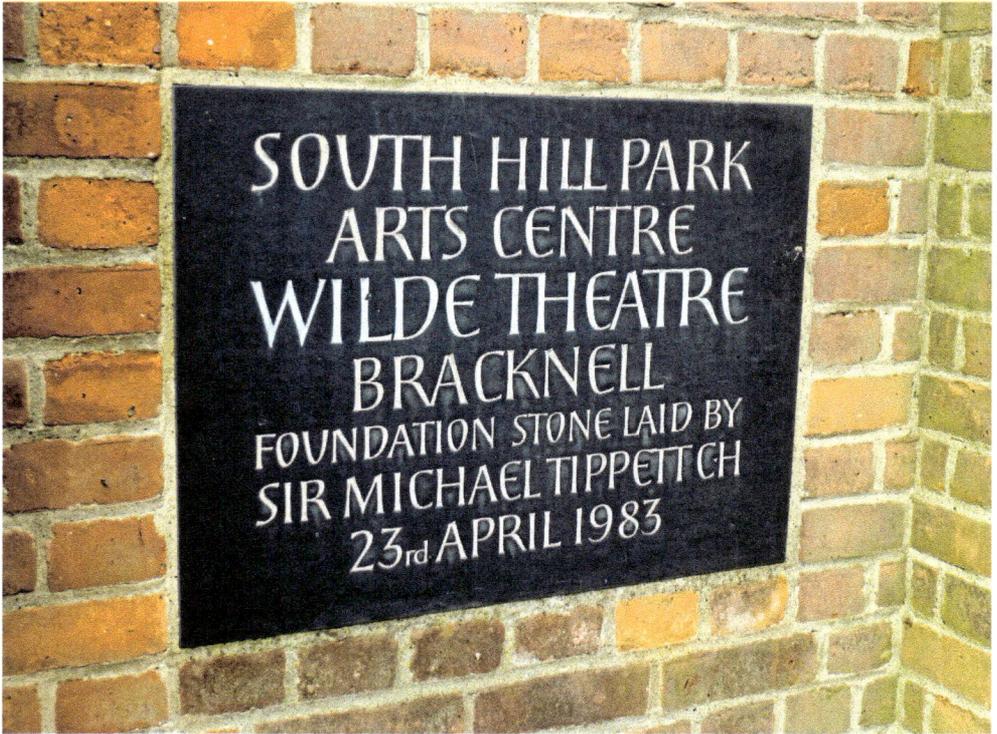

Board outside the Wilde Theatre.

from Waitrose, the Deputy Mayor of Bracknell, Councillor Mark Phillips and Geoffrey Taylor, Chairman of South Hill Park Trust combined to cut the ribbon and declare the new venue open. During the evenings it will be used for concerts, solo performances, poetry readings and a variety of other events. During the daytime the bar will be open for friends to meet and chat over coffee.

No doubt in the future there will be other additions to this popular and flourishing Arts Centre.

7. Pubs and Roast Dinners

By the mid-nineteenth century Bracknell had become known as a coaching town. Horse-drawn coaches travelled long journeys and they needed rest. As Bracknell was on the main road between Ascot Heath and Reading, there were a number of coaching inns which are still open for business today. Several of them are very old and have the status of Grade II-listed buildings. Most provide facilities for watching major football matches and customers can also take part in darts and pool competitions. Some have children's play areas and most provide delicious Sunday lunches.

The Sunday roast has been a tradition for many years and is also greatly appreciated by foreign visitors. In 1698 a French visitor to London, Henri Misson, wrote: 'It is common practice even among people of good substance to have a huge piece of roast beef on Sundays, of which they stuff until they can swallow no more and eat the rest cold, without any other victuals, the other six days of the week.' Originally the meat would have been cooked over an open fire. Although this is no longer done, the term 'Sunday roast' has remained. The Yeomen of the Guard are still called 'Beefeaters', a term that originated in the fifteenth century.

In earlier days landowners would provide a meal of roast meat and potatoes on Sundays for their servants when they returned from attending the morning church service. The meat would have been put on the spit before the service so that it would be cooked by lunch time. Today, although roast beef is still a favourite, turkey, lamb and pork are often offered as alternatives.

The Red Lion

The Red Lion in the High Street, a Grade II-listed building, is a very old coaching inn and one of the very few original buildings left in the town. On 20 January 1845, Queen

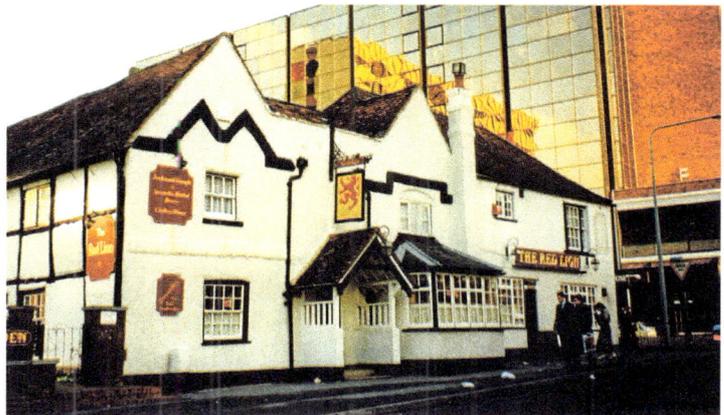

The Red Lion. (Courtesy of Eileen Briggs)

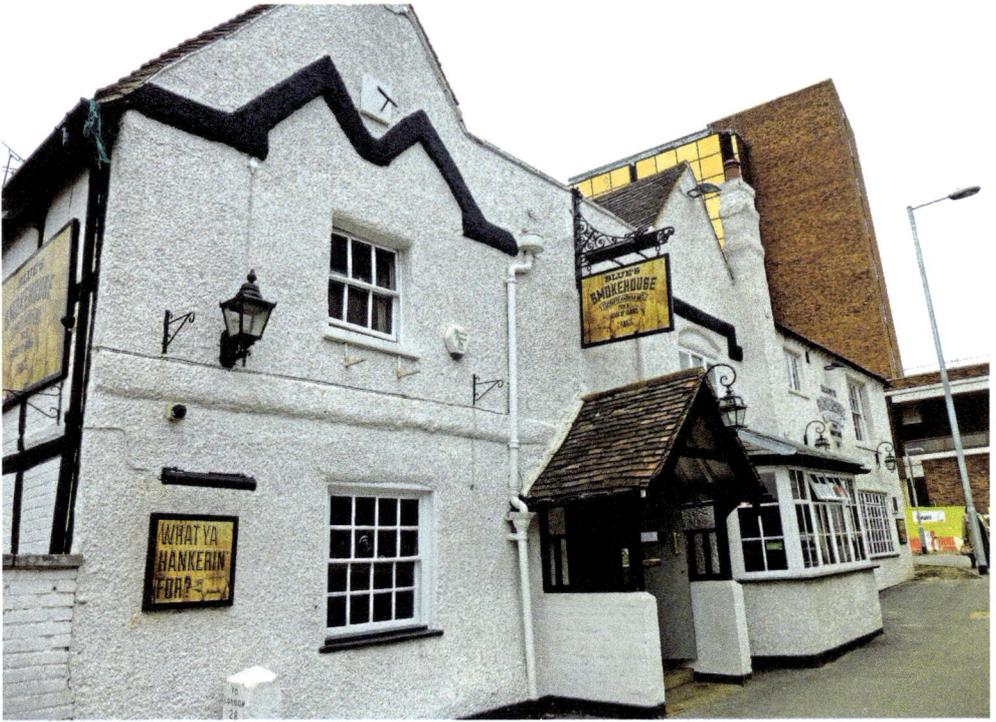

Above: The Red Lion, now a smokehouse.

Left: A milestone outside the Red Lion.

Victoria stopped outside the inn on her way to visit the Duke of Wellington in Stratford Saye. She was presented with a bouquet by a small child and entertained in the building; her coachman, meanwhile, unhitched the tired horses and attached fresh ones from the stables so that the queen could continue her journey in comfort.

The Red Lion is now a blues smokehouse, an American style barbecue restaurant. Apparently the meat is always smoked for several hours before being served to customers, which gives it a distinctive taste. Although the restaurant is a listed building, the name Red Lion had been obliterated and replaced with Blue's Smokehouse.

In front of the Red Lion is a milestone which is also Grade II-listed. This has been recently painted and the black to '28 London' stands out against the gleaming white of the rest of the pillar.

The Bull Inn

Also situated at the end of the High Street is the fifteenth century Bull Inn. On 20 December 1972 it, too, became a Grade II-listed building. The Bull was one of the coaching inns. The name refers to the popular sport of bull-baiting which took place in the vicinity and drew huge crowds of all classes. Tradition says that there are many underground passages linking it to other inns in the area. One of these is said to go to the top of the High Street to link with the infamous Hind's Head; this tunnel may have been used by Dick Turpin.

Like many old buildings, The Bull is supposed to be haunted but apparently the apparitions cause little trouble. However, the staff are annoyed when they discover that the beer taps have been tampered with. As the inn was near the gibbet in Quelm Lane, a man about to be hanged can occasionally be seen in the pub sipping his last pint.

When extensions were carried out in 1960, an old fireplace, thought to be Victorian, was discovered. The Bull, sadly, is now boarded up and its future is uncertain. Outside this pub is a very unusual fountain; a very large granite ball rotates in a cascading pool of water.

Another Grade II-listed building in the High Street is 'Prospect', an estate agent. This was originally 'Gingers', a butcher's and delicatessen.

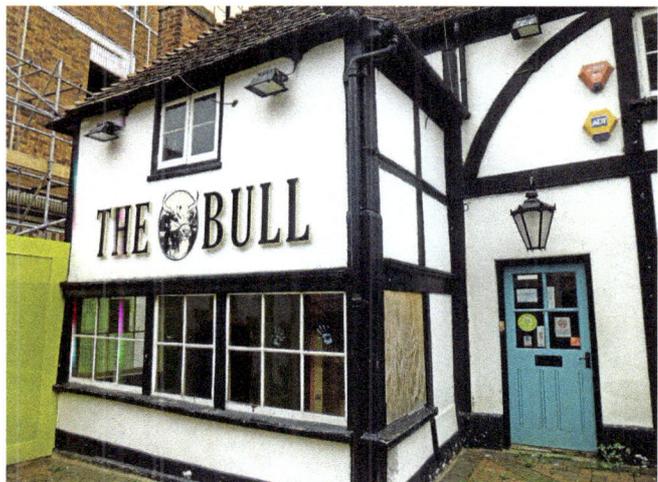

The Bull. (Courtesy of Eileen Briggs)

Fountain outside The Bull.

Prospects on the site of the former Delicatessen, Gingers.

The Hind's Head

The Hind's Head, another coaching inn, was built in 1465 and, like other inns in the area, had a number of underground passages where highwaymen could hide. One led to The Bull in the High Street and others to the Old Manor opposite. Horses were stabled behind the inn.

This inn was notorious for its unpleasant landlord, Richard Miller, who tricked his wealthy customers into sleeping in a particular bed. Underneath, was a trapdoor, through which the unlucky man was hurled after being robbed of his valuables. The 1832 'Year Book' states that bones were discovered in the well underneath the Hind's Head (*see* chapter 9).

After the capture and execution of Miller and his wife, the inn continued its legitimate business for many years under more pleasant landlords. In the twentieth century the pub was run by the Simms family from 1911 to 1939 and the ownership passed from father to son. The pub finally closed down and was later demolished. In the 1960s a College of Education was built on the site and this is still in use.

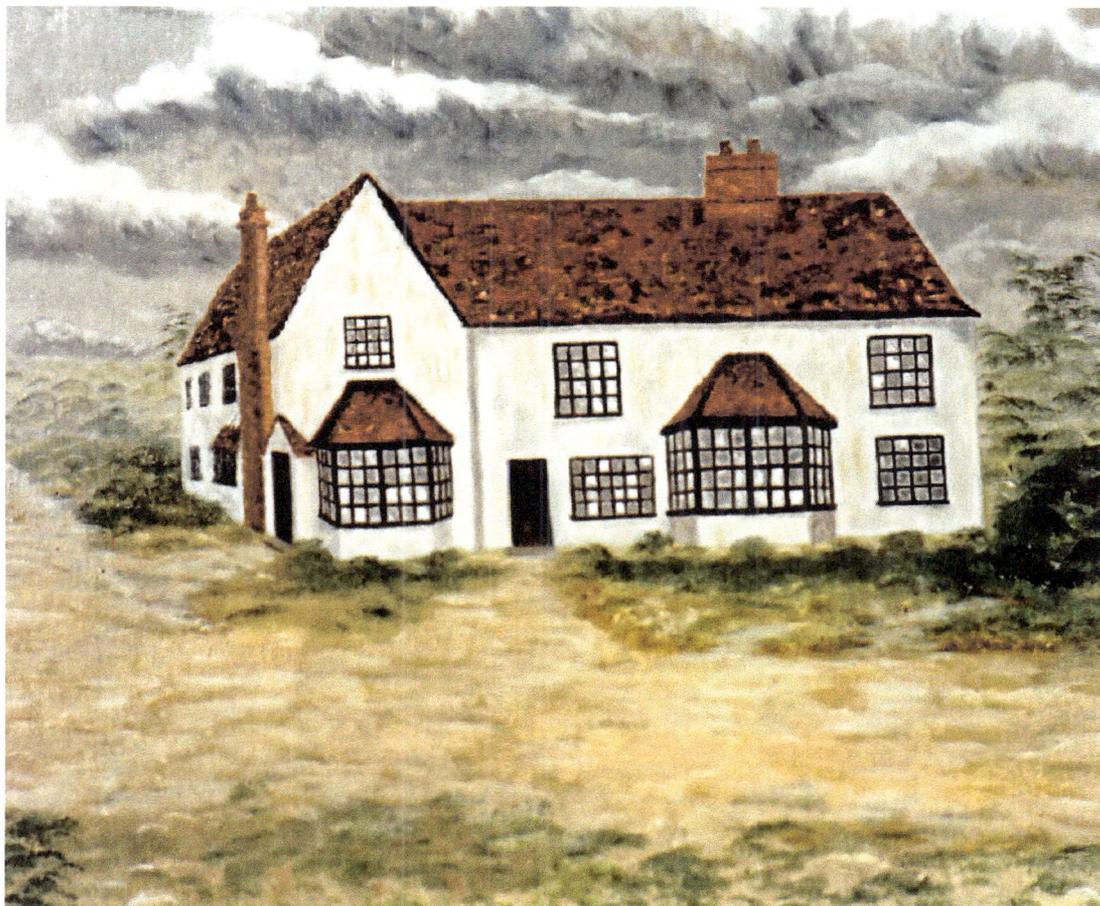

The Hind's Head. (Courtesy of Eileen Briggs)

Bracknell College on site of a former inn, 1990. (Courtesy of Eileen Briggs)

Bracknell College, 2016.

The Old Manor

The Old Manor, a seventeenth-century brick manor house, is one of the oldest surviving buildings in Bracknell. It was originally owned by a Catholic family and when the celebration Mass was banned, there was a small chapel which could be used. Nearby was a priest's hole where the priest could hide when the soldiers came searching for any who had broken the law. Apparently a hooded monk can sometimes be seen wandering around searching for a hiding place. Underground tunnels linked the manor to the Hind's Head inn opposite so the priest was able to escape. Another occasional visitor who haunts the bar is Bert, who first appeared in the 1970s sipping his pint. A portly gentleman, sporting a handlebar moustache and a large hat, his red face bears witness to his frequent imbibing in life.

The manor continued to be a private residence until the 1930s. Later, it was purchased by JD Wetherspoon but it has not forgotten its origins and photographs of old Bracknell decorate the walls.

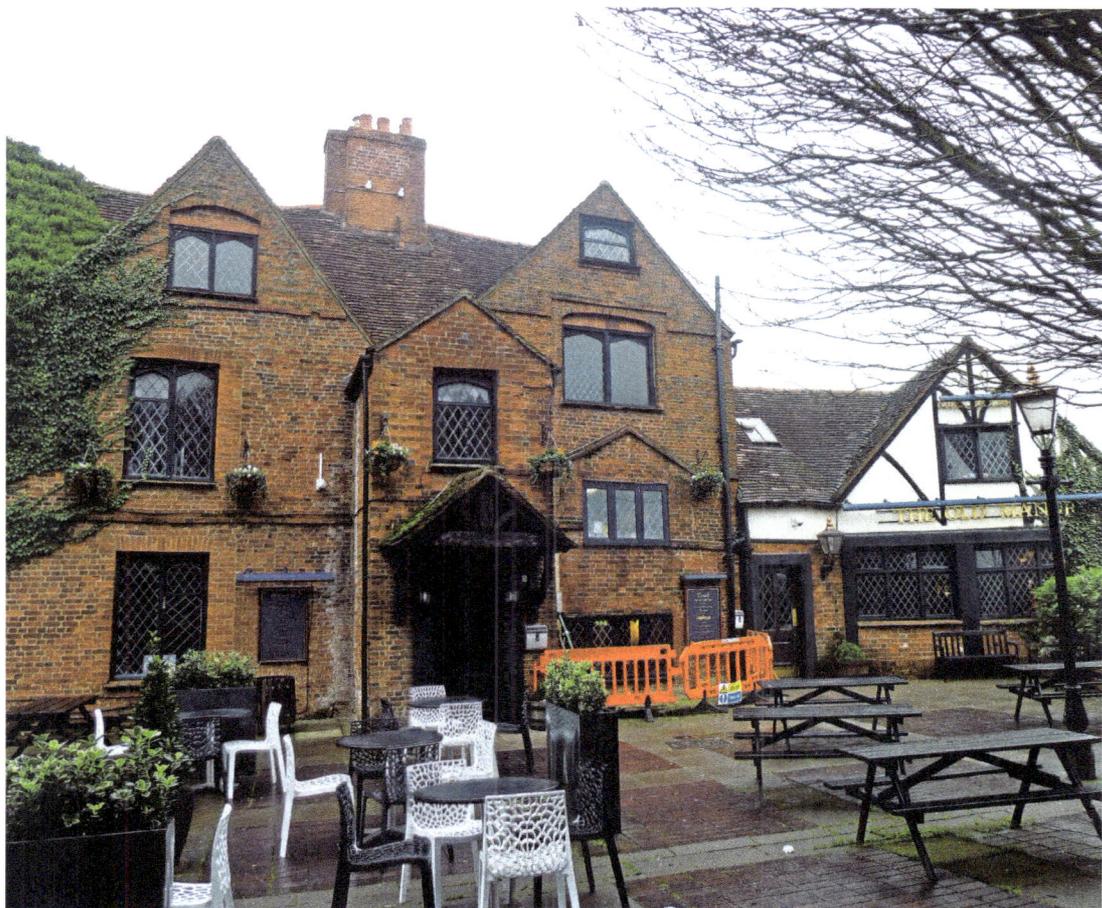

The Old Manor. (Courtesy of Eileen Briggs)

The Green Man

The Green Man, a Barras pub, in Wild Riding, was a coaching inn that was built during the sixteenth century. It also has underground tunnels linking with other pubs in the area. Today, it is definitely a 'sports pub'. Major football matches can be viewed on large screens. Not only spectators are catered for; there are teams for pool, darts and Sunday league football. When the weather is fine, visitors can enjoy their drinks in the beer garden.

The Horse and Groom

The Horse and Groom is now a Harvester. In 1810 there was a grisly murder nearby. Seventeen-year-old William Ware was walking home with his father when they were attacked by three thugs who beat them with cudgels. William was beaten unconscious and carried into the Horse and Groom where he died the following day.

During the nineteenth century, the inn had a number of landlords but from 1841 to 1868 the Sargeant family appear on the records as the 'Licensed Victuallers'.

The pub boasts two ghosts. During the 1950s an elderly lady was occasionally seen flitting about as she performed her duties. She was a 'friendly' spirit but another phantom has a taste for whisky. He is never seen but whisky apparently disappears from locked cupboards.

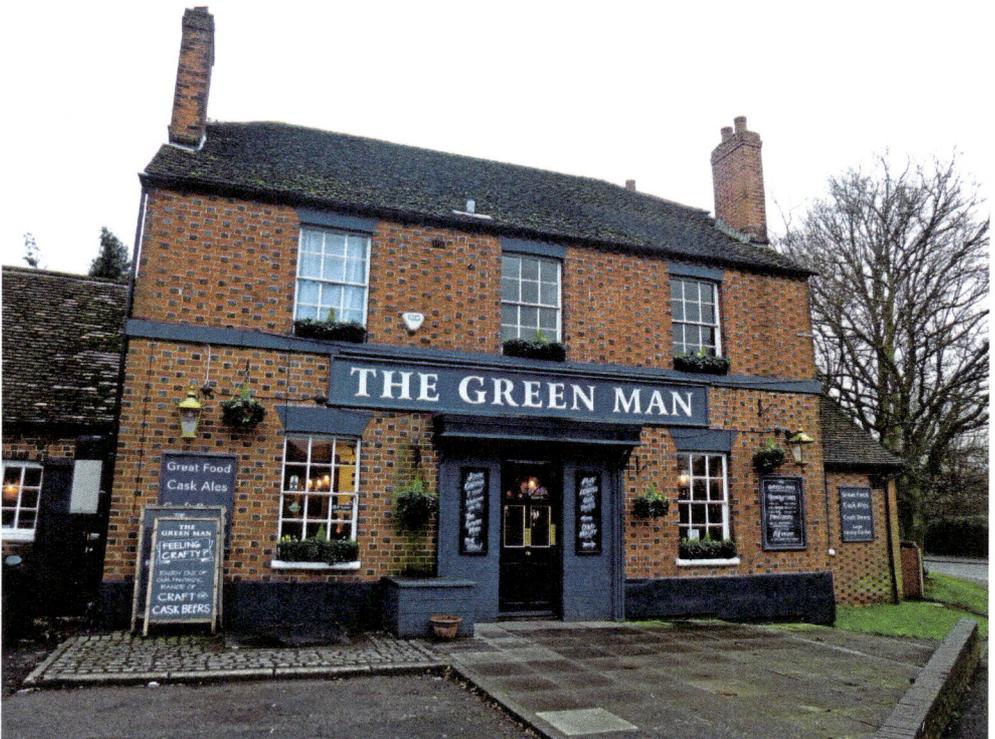

The Green Man.

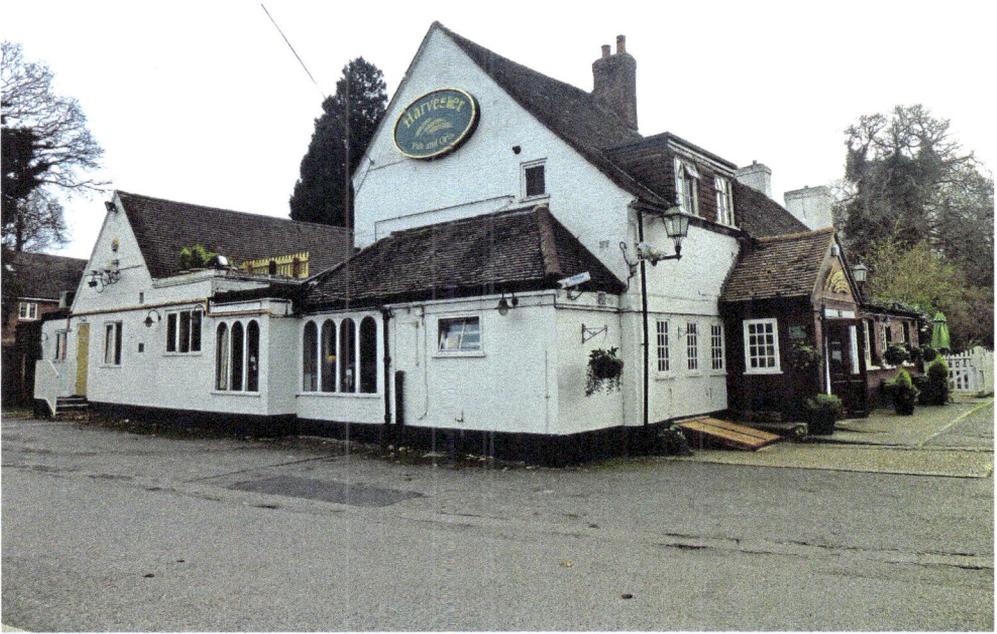

The Horse and Groom, now a Harvester, on Bagshot Road.

Bagshot Road, 1980. (Courtesy of Eileen Briggs)

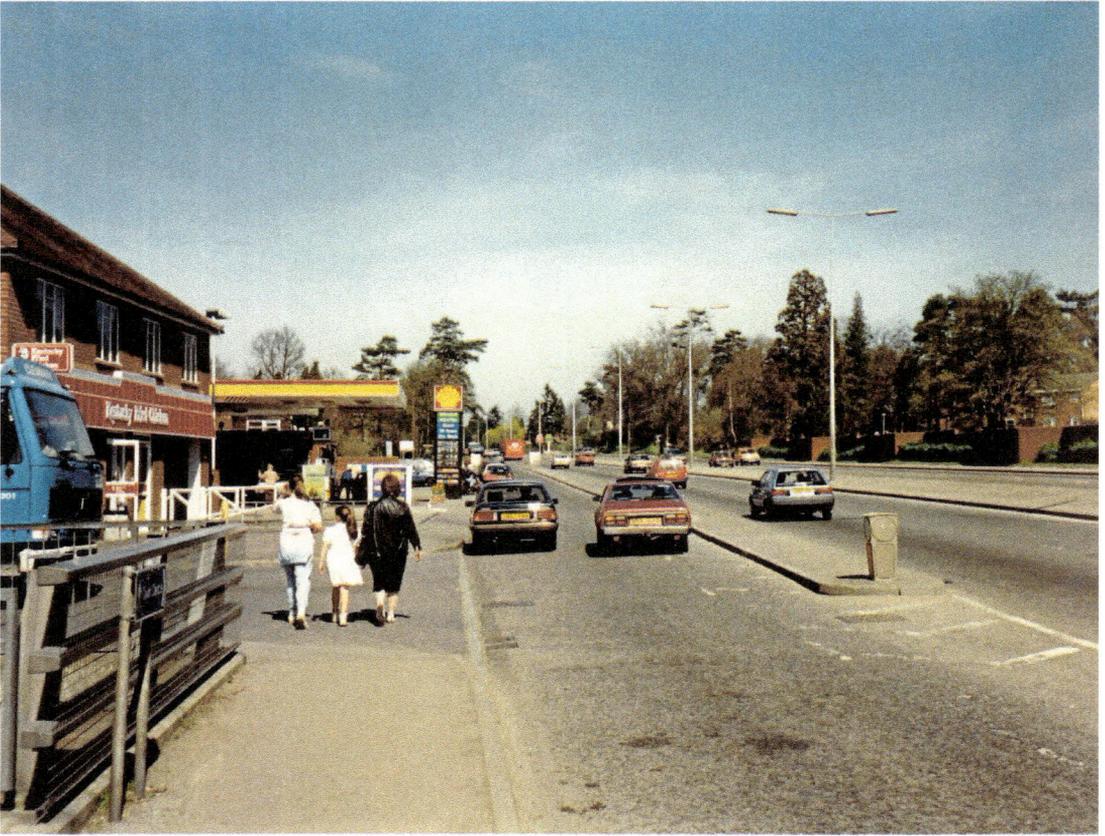

Bagshot Road, 1991. (Courtesy of Eileen Briggs)

The Golden Farmer

The Golden Farmer, a Greene King pub, is not as old as the other pubs in the Bracknell area but it has been built on the site of an earlier inn frequented by a notorious highwayman and named after him. William Davies was a wealthy farmer who lived in Gloucestershire with his wife and eighteen children. However, he made frequent trips to Berkshire to live his double life as a highwayman although he was different from the others. Unlike them, he only took gold from his victims. The rest of their jewellery and valuables he allowed them to keep. Other farmers in the Gloucester area were puzzled that he always paid his bills in gold. Much of his takings he kept for himself but he was also a philanthropist who was concerned about the poor. When he had held up a coach and collected a number of golden guineas, he would slip one under the door of a local man in need of help.[1]

He became known as the Golden Farmer and plied his trade for many years before he was finally caught and hanged in London. Tradition says that his body was then brought back to Bracknell and hung in chains on the gibbet in Quelm Lane. The present Golden Farmer is situated near the place where the gibbet once stood.

The Golden Farmer.

8. Entertainment and Leisure

Hunting

One of the oldest sports is, of course, hunting which was enjoyed by the Saxon kings and by many monarchs over the centuries. As part of Windsor Forest, Easthampstead was a popular hunting ground, particularly after Edward III established his hunting lodge there in 1350.

Henry VIII even had his own pack of buckhounds which later became known as the Royal Buckhounds. His daughter, Mary, a sickly lady, was not enamoured of the sport and discouraged it but it flourished again when her sister, Elizabeth, came to the throne; her successor, James I, was also an enthusiastic hunter.

A later queen, Anne, was devoted to the sport and enjoyed hunting on horseback until she was not able to ride any more. She then continued to follow the hunt in her carriage. Her successors continued the tradition but today there is no longer any hunting in Easthampstead Park as much of the land has now been built on.

Bull-baiting

One of the most popular sports in Bracknell was bull-baiting and the town became famous for its bull fights. Bulls were expensive animals so it was the wealthy who provided the animals for the sport. They also owned the bulldogs who fought the bulls and promoted the contests. The bulldogs usually won and the proud owners of the winners were presented with tokens which were then attached to the silver collars around the dogs' necks. Perhaps to assuage their guilt about the cruelty inflicted on the poor bulls, many of the patrons insisted that the meat from the dead animals should be given to the poor. Their hides were used for making shoes.

The most popular day for bull fights was Good Friday and crowds would throng round The Bull Inn in the High Street to watch the entertainment. This came to an end in 1821 when bull fights were prohibited in Bracknell although the poor were still provided with meat from the bulls on Christmas Day. Bracknell was ahead of the times as it was not until 1833 that an Act of Parliament finally banned this cruel sport.

Horse Fairs

In the nineteenth century and early twentieth, three horse fairs were held annually in April, August and October. The events were recorded in Old Moore's Almanac.[1] In Bracknell, horses were brought from the surrounding area to take part in the fairs which were very popular events. As well as the horses, there were other amusements for visitors to enjoy. In nearby barns strolling players put on popular shows, quacks used electric shocks to cure 'incurables' and there were even beauty competitions. However, no ladies were present for these. The judges had to decide on the winner by poring over photographs of the contestants. The fairs stopped when the weekly cattle market was established.

DID YOU KNOW THAT…?

The three Bracknell fairs held annually in April, August and October provided onlookers with the opportunity to enjoy the sports of bull-baiting and cockfighting as well as other amusements. The October fair was known as a 'Hiring Fair' as employers could look for and hire new servants. This was very useful as a number of new country houses requiring servants were built in the nineteenth century as Bracknell was considered to have a very healthy climate.

Countryside Pursuits

Bracknell today may be a new town but the area provides many opportunities for those who enjoy the outdoor life. There are over 150 varied sites for this. There are country lanes through wooded meadows, nature reserves where wildlife can be observed and eighty play areas for children.

For prospective walkers, there are many footpaths, including public rights of way through Bracknell Forest, and there is a wealth of information available. The Ramblers' Route is a 26-mile walking trail for the energetic which is clearly signposted. Other leaflets promoting trails around the borough can be picked up at a number of venues. *Accessible Rural Routes* suggest a number of short walks suitable for those less mobile including the disabled.

Opportunities for orienteering can provide a challenge for both children and adults.[2] Pope's Meadow, named after the poet Alexander Pope, has a permanent orienteering course already mapped out. The meadow also contains a variety of wildlife and a toddlers' play area.

Lily Hill House was built in the nineteenth century. In 1807 it was bought by Henry and Isabella Vincent and then passed to their son, Henry. When he died in 1865, it was taken over by Lt-Col. Lane who was married to Henry's daughter. In 1902 he sold it and, after that, it had several owners before the house and land were bought by Bracknell Development in 1955. They leased it to Ferranti Ltd, the computer manufacturer.

A huge computer, known as Apollo, after the Sun God, was built, tested and developed on the ground floor drawing room of the nineteenth-century house. By the time it was completed, it almost filled the room. Destined for Prestwick Airport, it was too large to transport so had to be taken apart for its journey and reassembled on arrival. Once installed, it was able to plot the position of planes and thus to become involved with commercial air traffic control.

The second computer to be built, tested and developed at Lily Hill House was for military use. It was to be used by the Royal Navy on the aircraft carrier HMS *Eagle*, based in Plymouth. Appropriately named after Poseidon, the God of the Sea, it too had to be dismantled before it could be transported; once installed, it linked up with the ship's radar. Used for air traffic control, it could communicate with other ships in the area and also detect any enemy aircraft that had invaded British air space.

Bracknell does not forget this part of its heritage. The roads in one of the newly developed areas near Easthampstead Church are all named after computer pioneers.

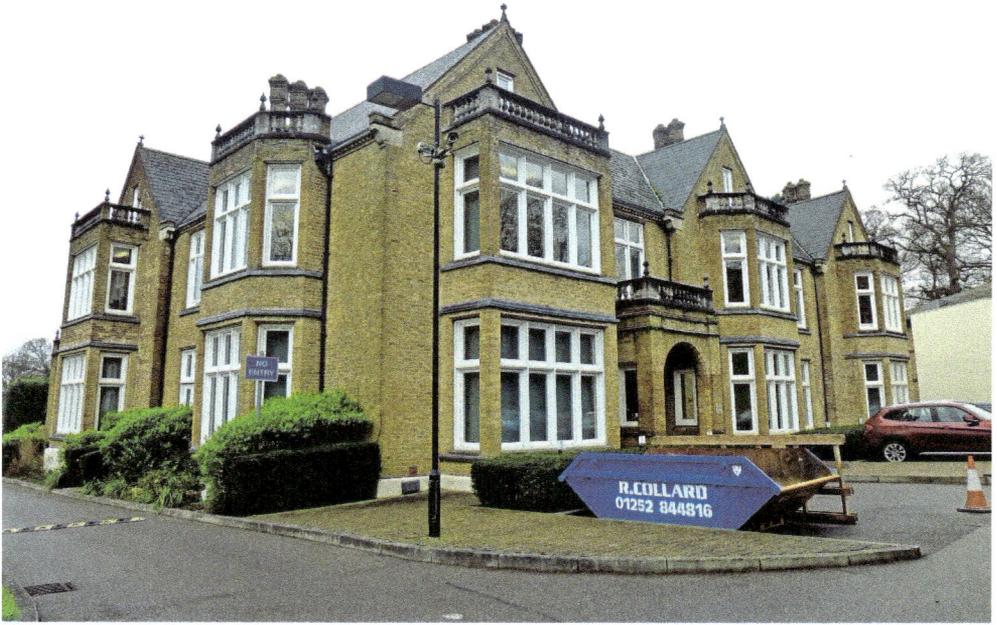

Lily Hill House, 2016.

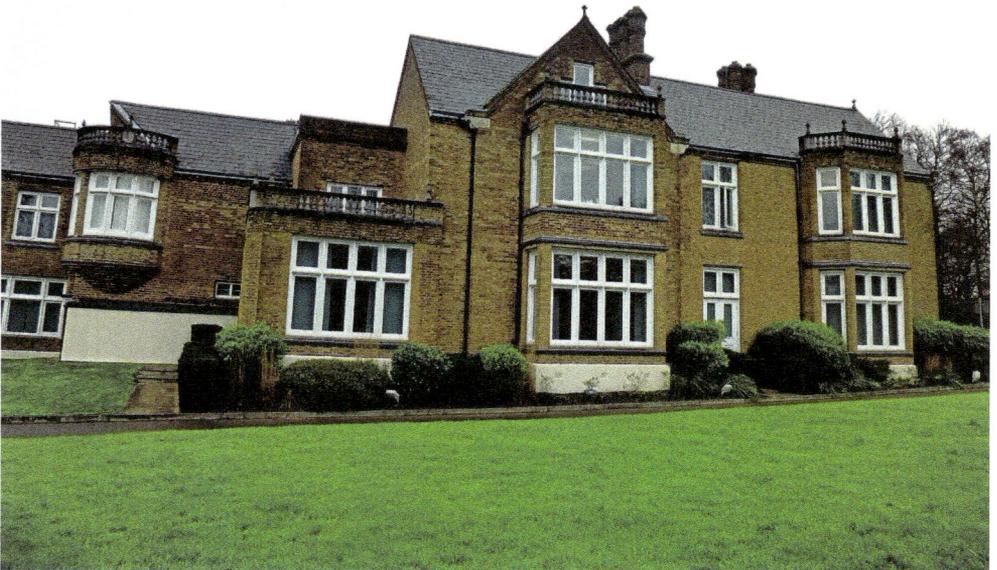

Side view of Lily Hill House, 2016.

Computers in Lily Hill House, 1950s. (Courtesy of Mike and Maggie Stevenson)

Lily Hill Park.

Turing Drive.

One of them is Turing Drive. Alan Turing was one of the code breakers who worked at Bletchley Park during the Second World War.

Recently, money from the Heritage Lottery Fund has restored the park area to its former glory. There are formal gardens originally created in the eighteenth and nineteenth centuries and also a permanent orienteering course. Lily Hill Park also provides a secluded setting for the Bracknell Lawn Tennis Club. This Clubmark accredited club has excellent facilities with a modern clubhouse and five floodlit courts enabling players to play throughout the winter. Each week there are five club sessions and practice nights for both male and female teams as well as opportunities for juniors. Singles and doubles competitions are held regularly.

Mill Park, managed by Bracknell Town Council, is another area with plenty of wildlife and provision for a number of recreational activities. There are two children's play areas, football pitches and even a skate park.

Longhill Park also possesses a skate park which is the largest one in the borough. This contains a large number of trick-orientated objects including a large ramp and a bowl. The area is a reclaimed refuse site to which wildlife has now returned. As it is fairly flat, it is easily accessible to those less mobile. This Wildlife Heritage site is very popular with walkers and families.

Cycling is also a popular way of appreciating all aspects of the countryside. There are many country lanes free from air polluting vehicles; forest maps with cycling trails can

be obtained from The Look Out on the Nine Mile Ride where cycles are available for hire. This also contains an interesting science discovery area and a play site. When the children are hungry, they can join their parents in the picnic area or the café.

Another healthy activity that can be enjoyed is horse riding which is extremely popular in Bracknell Forest. North of the town is the Binfield Bridle Circuit. Ten miles long, it contains a number of bridle paths and quiet county lanes where riders can enjoy the sights and sounds of the countryside.

For those who prefer a more leisurely pursuit there is fishing. The two angling societies provide fishing permits for use in the River Blackwater and the balancing ponds. Bracknell Forest also hosts a number of events and activities throughout the year. There are wildlife talks by experts, guided countryside walks and educational events including bug-hunting and pond-dipping.

Cricket

On 7 May 1881 the *Reading Mercury* noted that 'a most successful concert took place in Bullbrook schoolroom on Monday evening in aid of providing a tent for Bracknell Cricket Club.' The 'tent' would presumably serve as a makeshift pavilion. In 1886 the club came up with another idea for raising money. An annual sports day was held. Crowds paid to watch athletics, cycle racing and other events. Later, a fair was even added. This event continued for a number of years and enabled the club to replace the tent with proper facilities. In 1887 the *Reading Mercury* was able to report that 'the ground is in splendid order, and the addition of a permanent dressing and scoring room will contribute greatly

Board outside Bracknell Cricket Club.

Cricket field in Larges Lane.

The Cricket Pavilion.

to the comfort of members'. Another innovation was the introduction of a Cricket Week. The first one was in 1886 during the August Bank Holiday week and it continued to be held until the Second World War.

When the First World War disrupted the cricket, the field was let to a local farmer to graze his cattle and the pavilion became a cow shed. After the war, the grounds and pavilion were restored to their original use and in 1922 the *Reading Mercury* reported that 'the ground is in excellent condition'. During the Second World War when regular fixtures were cancelled, Sunday cricket was introduced.

The club continued to use the same ground until the 1950s when it moved to Larges Lane on a site adjacent to the football ground. On 19 April 1955, the Duke of Edinburgh opened the new ground which the club still uses. Before the duke arrived, the dirt track leading to the ground had to be resurfaced so that his car could drive as near as possible to the pavilion. The score-box was erected in memory of Eric Taylor who had been secretary of the club for thirty-one years. Next to it is the Memorial Mound erected in memory of Alec Bedser who had been closely associated with the club. It contains ancient stones and flowers of remembrance. The cross on the top is formed by two stumps with a bail on top. Known as Memoria Myosotis (Remember not to Forget), it now commemorates all those from the Bracknell Cricket Club who have died in the service of their country.

A number of very prestigious matches have been staged in Larges Lane and several famous players including the Bedser twins, Laker and May have graced the ground. Some members of the present English Test Team have also played there. The club fields junior teams who train on Thursday evenings while the seniors practise on Tuesday evenings.

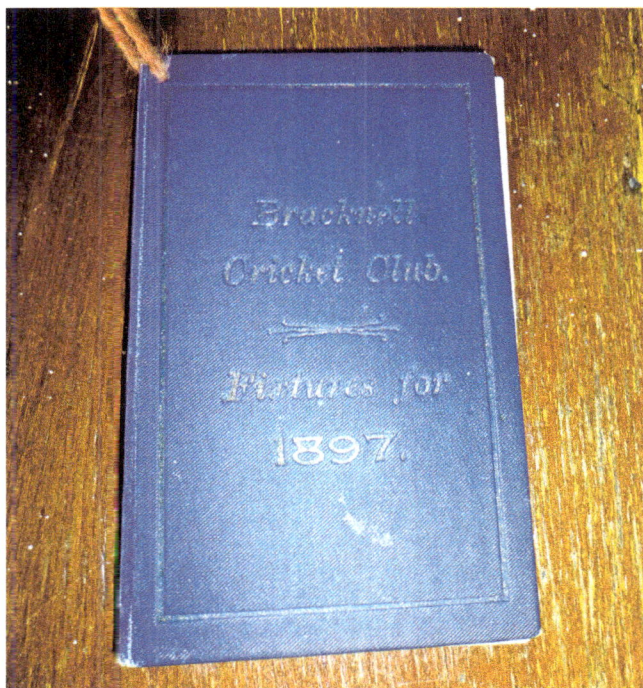

Cricket scorebook, 1897.
(Courtesy of Paul Marlow)

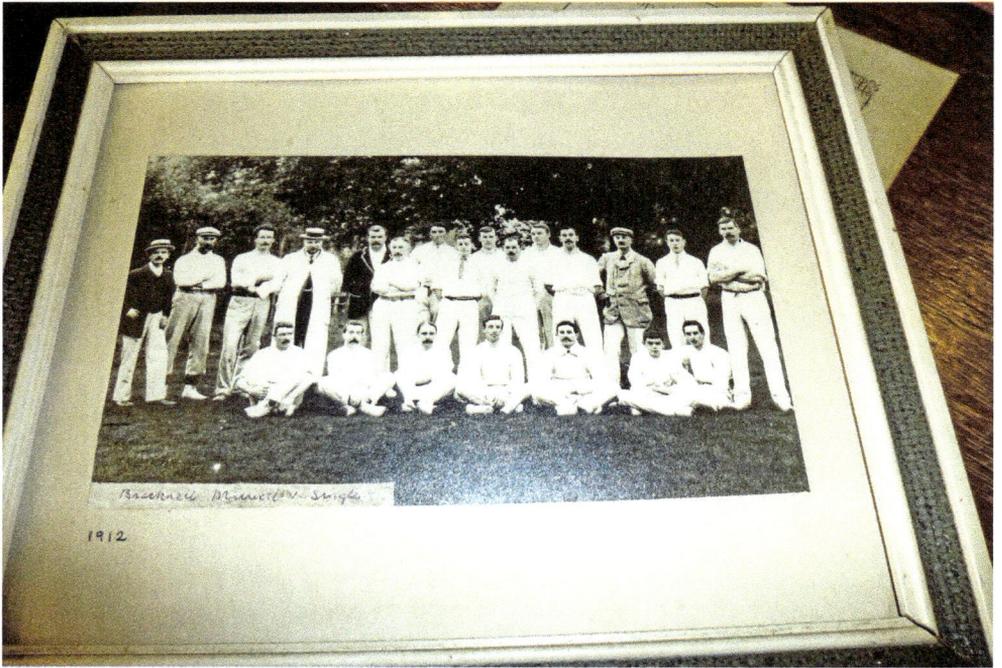

The cricket team in 1912. (Courtesy of Paul Marlow)

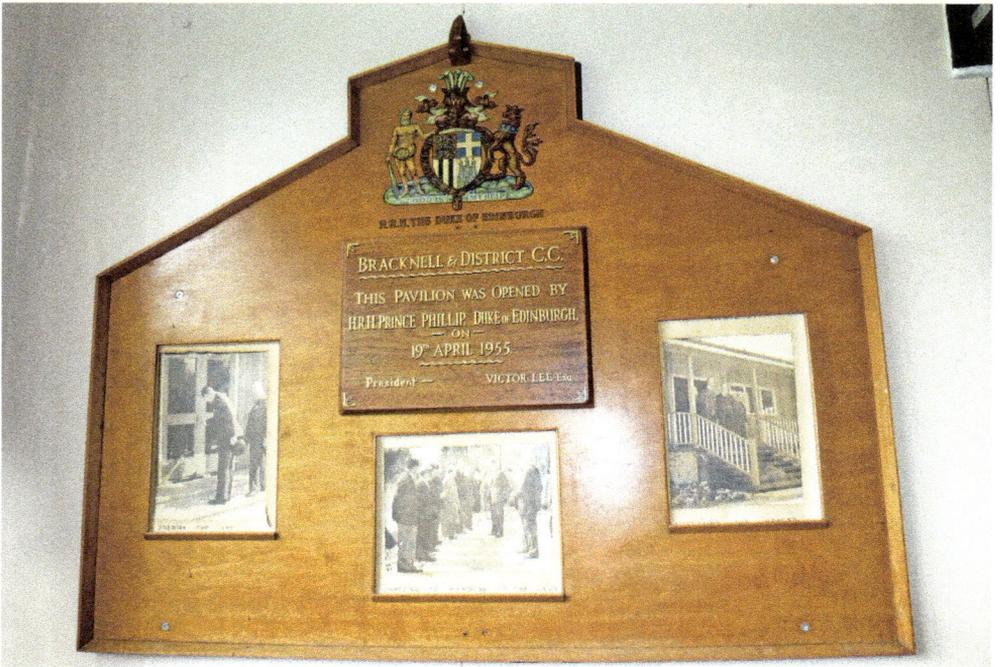

Board showing the opening of the new Cricket Pavilion in 1955. (Courtesy of Paul Marlow)

Right: A cricket bat presented by Alec Bedser. (Courtesy of Paul Marlow)

Below: Paul Marlow, the groundsman, with the spiker and slitter between the scoreboard and the Memorial Mound.

Matches are played at weekends and during the evenings. Some also take place in the middle of the week. Over the years, the club has had many successes and continues to flourish. In 2012 the club received the ECB Clubmark accreditation. This was a great achievement and well deserved.

The grounds are kept in pristine condition by Paul Marlow, the groundsman for over forty years. In the autumn he still uses the ancient 'spiker and slitter' which aerates the grass.

Those who prefer to be spectators can take out a social membership; a licensed bar is open when matches are being played.

Football

Bracknell Football Club, originally known as the Old Bracknell Wanderers, was formed in 1896. In the 1930s it moved to its present ground in Larges Lane. In 1949 the name was changed to Bracknell Football Club and the players acquired the nickname The Robins. In 1920 Dr Edward Fielden, who owned the Forest Hotel, had presented a cup for a local sports team. He hoped to raise money for the Royal Victorian Nursing Home in South Ascot. In 1951 Bracknell won the Cup. The Forest Hotel is currently boarded up and its ultimate fate has yet to be decided.

In 1962 the club was renamed Bracknell Town Football Club, a name it still bears. It played in the Surrey Senior League and in the 1969/70 season won the championship. Promoted to the London Spartan League, it won that championship in 1981. The team's highlight came in 2000 when it reached the first round proper of the FA Cup. Currently,

Board outside the Bracknell Town Football Club Café.

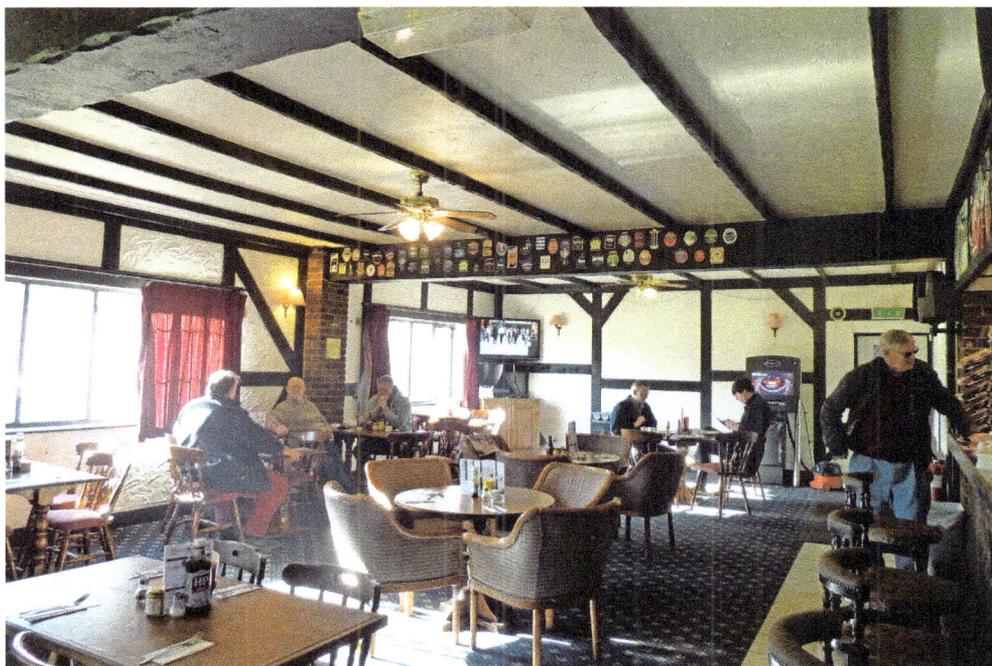

Inside Football Club Café.

Lawrence Humphrey behind the bar chatting to John Bassett, to whom this book is dedicated.

Bracknell plays in the Hellenic League but recently they have had little success and crowd numbers are dwindling. In 2015 the council offered the club a new ground but it was not large enough to cater for Bracknell's many teams so the club continues to play in Larges Lane to the relief of the local inhabitants. The club boasts an attractive café which serves breakfast and light lunches throughout the week.

There is a move afoot to sell part of the ground for redevelopment so that the existing facilities can be improved. It is hoped that planning permission will be granted for this before the end of the season in 2016.

Bracknell Bowling and Social Club

Bracknell Bowling and Social Club originated in the 1890s and in 1972 it moved to its present prime position in Church Road. It was still a men's club although women were permitted to join as Associate Members. It was not until the annual general meeting in 1974 that the ladies were admitted on an equal footing with the men.

The modern clubhouse has excellent facilities with three snooker tables, an area for indoor bowling during the winter months and a large television screen for watching football matches. Regular entertainment is provided in the form of quiz nights, live music and comedy shows.

Bowling green in Church Road.

Music and Cinema in Bracknell

During the nineteenth century, a rough music band was used to show disapproval of unacceptable behaviour. Disorderly conduct, wife beating and drunkenness were among the offences which roused the ire of the 'musicians'. They would bang trays, buckets, saucepans and any other appropriate utensils outside the offender's house. They continued the 'performance' until he promised to mend his ways.

As there was no concert hall or theatre in the town, the Victoria Hall was used. This also showed films and, until 1930, housed the Sunday school every week. In 1934 the Regal Cinema opened. The first film shown was *The Silent Voice* starring George Arliss. Present for the performance were two of Queen Victoria's granddaughters, the Princesses Victoria and Marie Louise, who were living in nearby Sunningdale at the time. During the reorganisation of the town in the 1960s the cinema was demolished and replaced by an office block.

In 1952 The East Berkshire Operatic Society was founded. The first production, *HMS Pinafore*, was performed in the Victoria Hall in 1953. For nine years the society produced a Gilbert and Sullivan operetta annually During the 1960s and 1970s the number of shows gradually increased and, in 1976, three very different musical events were put on; these were *Oliver*, *The Mikado* and *Guys and Dolls*.

The St John's Ambulance Brigade, founded in 1932, provided a twenty-four-hour voluntary service for many years. The Victoria Hall would annually host their Old Time Dance. During the 1940s and 1950s, the Victoria Hall continued to be well used. A group called the Bracknell Mummers often entertained and a group of young people known

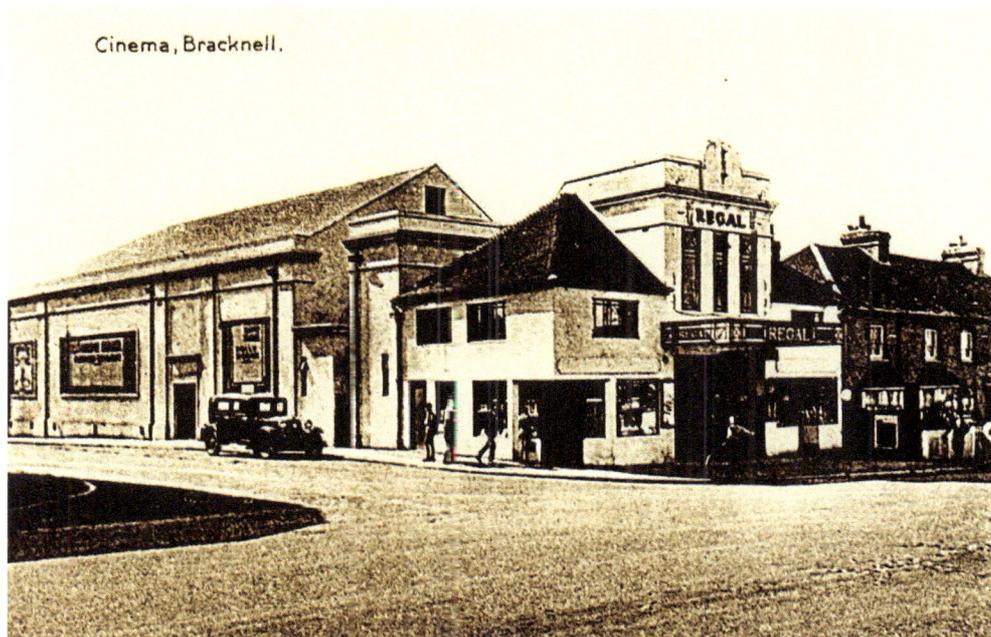

The Regal Cinema. (Courtesy of Eileen Briggs)

Building on the site of the Regal Cinema, 1990s. (Courtesy of Eileen Briggs)

Building on site of the Regal Cinema, 2016.

as The Young Hopefuls produced a musical song and dance show every year using spectacular lighting. When the Victoria Hall was demolished, the society continued to perform in the Wilde Theatre at South Hill Park. Each year audiences can still enjoy an operetta and a musical. Pantomimes and music halls are sometimes performed and the 'Carol Sing' is popular at Christmas.

DID YOU KNOW THAT…?

The productions at Victoria Hall were so popular that sometimes celebrities were in the audience. On one occasion there was great excitement when Doris Day drove up in a large limousine to watch a performance.

9. Famous and Infamous Residents

St Birinus

St Birinus was a seventh-century Benedictine monk from a monastery in Rome. In AD 634 Pope Honorius I sent him to England to convert the Saxons in the South of England. In 635 he landed on the South Coast and made his way to the Thames Valley. Here he met Cynegils, King of the West Saxons. Cynegils was impressed by the monk and converted to Christianity. He was baptised and, as a result, Christianity spread throughout the south and west of England.

St Birinus built an abbey church in 'the city of Doric' (Dorchester). He died on 3 December 650 and was buried in the church he had founded. There is little doubt that, at some time, he visited the Bracknell area as he is remembered by a stained-glass window in the south transept of Holy Trinity Church in Bracknell. He is depicted holding a model of the abbey church in Dorchester. In AD 680 his remains were moved to Winchester and, on 4 September 972, Bishop Ethelwold had the relics enshrined in silver and gold. It is thought that they still reside in a chest in Winchester Cathedral.

After his death, shrines were erected to him but these were destroyed at the Reformation. Recently, a new one incorporating some of the stones from one of the original shrines was erected in the abbey church in Dorchester where it can still be seen. St Birinus's Feast Day is celebrated on 5 December and today worshippers attend a more modern St Birinus Catholic Church in Dorchester.

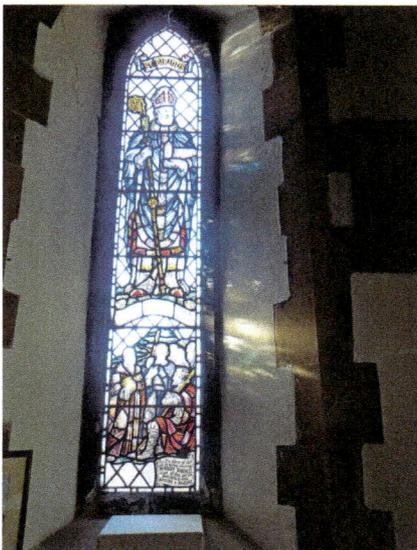

Stained-glass window of St Birinus.

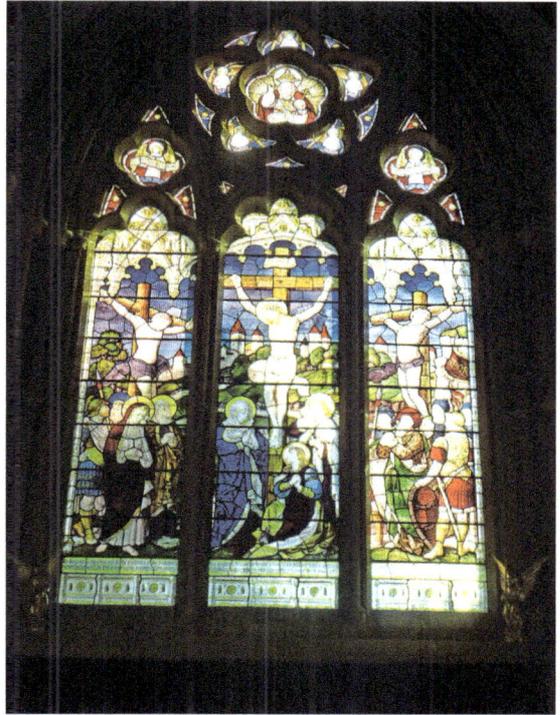

East window in Holy Trinity Church.

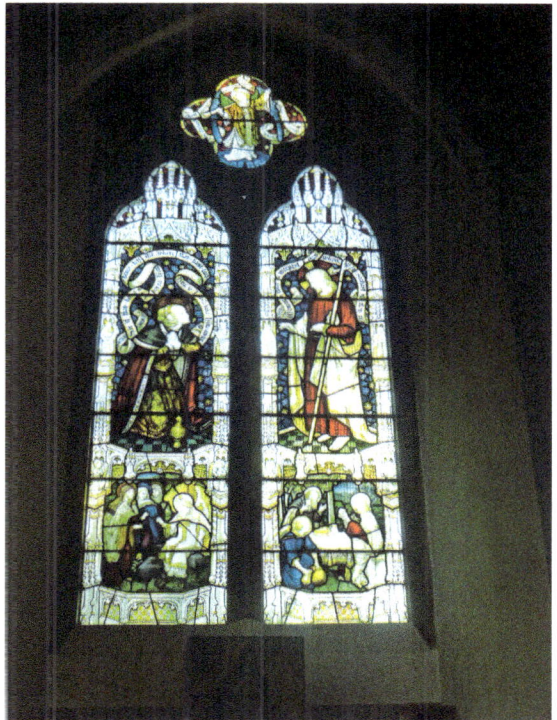

Windows in Holy Trinity.

Alexander Pope

Alexander Pope was born in London on 21 May 1688. He was the son of a prosperous linen draper. He was a sickly child and suffered badly from asthma. In 1700 his father retired and the family moved to Binfield, near Bracknell. Soon after he arrived there, Alexander contracted tuberculosis and this probably stunted his growth as he never grew above 4.5 feet tall.

Perhaps his small stature and continuing ill health made him vain and precocious. In later life, his irritability enabled him to write a number of biting satirical poems, often aimed at his friends. Whatever his shortcomings, he, nevertheless, became one of our most famous poets.

Pope had a brilliant mind but, as a Roman Catholic, he was debarred from entering university in the eighteenth century. Consequently, he set out to educate himself. He taught himself Latin, Greek and some modern European languages. He started his writing career at an early age. When he was twenty, he wrote his 'Essay on Criticism' and, by the time he was twenty-six, he had written some of his most famous poems including 'The Rape of the Lock'.

During this period, he became very friendly with the recently retired Sir William Trumbull from South Hill Park. It was Sir William who encouraged him to translate some of the works of Homer. He dedicated his poem 'Spring Pastoral' to his mentor. He also introduced his friend, Elijah Fenton, as a tutor for Sir William's young son, also called

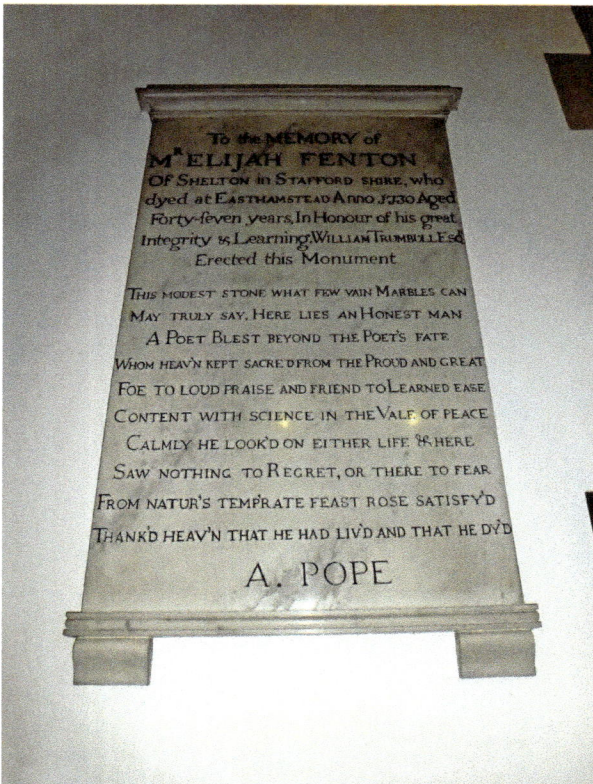

Memorial to Elijah Fenton.

William. In 1726 Fenton accompanied the young man to Cambridge. Fenton later found a house in Easthampstead where he lived for the rest of his life.

When Sir William died in 1716, Pope wrote a flattering epitaph for him:

> A pleasing form, a firm yet cautious Mind
> Sincere, tho prudent, constant yet resigned.

When Elijah Fenton died in 1730 at the early age of forty-eight, Pope also wrote an epitaph for him and this one has been incorporated into the memorial for Fenton in Easthampstead Church.[2]

Having achieved success as a writer, Pope moved back to London but his health gradually deteriorated and he died in 1744. Pope's Meadow in Binfield is a memorial to this great poet.

DID YOU KNOW THAT...?

Reeds Hill Farm, an old timber-framed house is situated on Reeds Hill near the church in Easthampstead. Tradition suggests that Percy Bysshe Shelley, the poet, rented the farm in 1814 when he was married to his first wife, Harriet. The marriage was not a happy one and the poet looked elsewhere. He fell in love with a local lady called Cornelia Turner who lived nearby. It is not known for how long their relationship lasted. Shelley and his second wife, Mary, also lived 'near Windsor Great Park' and their house could have been Reeds Hill Farm.

Dick Turpin

The name of Dick Turpin is well known. He was born in the Bell Inn in Hempstead in Essex in 1705. Even when working as a legitimate butcher in his home village, he would buy deer that had been stolen from Epping Forest. To poach deer at this time was a capital offence as all those animals traditionally belonged to the Sovereign. Soon, Turpin became dissatisfied with such a minor offence as 'receiving stolen goods'. He joined a gang of fifteen ruffians led by one Samuel Gregory. Together they terrorised the neighbourhood raiding farmhouses, torturing the inhabitants and stealing their valuables. Turpin's life as a notorious highwayman had begun.

For the next ten years from 1725 to 1735 he travelled around the country, holding up carriages and amassing a fortune from his victims. Innkeepers round the country knew him and, in fear of their lives, gave him shelter. Bracknell was one of his popular haunts and he could often be seen galloping down Ralph's Ride. The Old Manor was a frequent stopping place and became known as Turpin's Cottage. There was a tunnel leading to the Hind's Head Inn opposite the Old Manor.[1] As this was large enough to house a mounted rider, it provided an excellent hiding place for Turpin and his famous horse, Black Bess. He was a frequent visitor at both hostelries.

He retained links with his original gang but, in February 1735, three of them were captured and hanged. Two more tried unsuccessfully to flee to the continent but met the same fate. Turpin was more fortunate as he was able to reach Holland where he stayed until 1737 when England beckoned once more. As there was a price on his head, he changed his name to John Palmer. He did not, however, change his ways and was eventually captured in York where he was incarcerated in a prison cell. While there, he made the mistake of writing to his brother in Essex using his assumed name. Unfortunately for him, the letter fell into the hands of his old schoolmaster who recognised Turpin's handwriting.

The highwayman was moved to London and hanged at Tyburn on 7 April 1739. Crowds had come to watch and Turpin, ever the showman, did not wait for the ladder to be removed but jumped off it to the delight of the watchers who had come to see the notorious Dick Turpin meet his deserved end.

DID YOU KNOW THAT...?

In the eighteenth century, a particularly vicious gang of twenty-nine ruffians known as the Wokingham Blacks, led by one William Shorter, terrorised the neighbourhood for several years. In 1723 they had a pitched battle with a troop of mounted Grenadier Guards. Their reign of terror eventually ended when one of their number was forced to reveal that a secret meeting of the criminals was to be held at the lodge near Caesar's Camp. The sheriff and his men lay in wait and arrested the gang when they had all arrived. Shorter was later hanged at the county boundary.

George Canning

George Canning was born in 1770. His father was a barrister who, to the disgust of his family, married a beautiful Irish girl. For this he was disinherited and, sadly, he died before his son was born. His widow tried to make a living on the stage but failed; she later married a draper and had five children by him.

George, her son by her first marriage, went to Eton and entered parliament as the Tory MP for Newport in the Isle of Wight, 1794. He was a supporter of William Pitt, the Prime Minister and in 1796 Pitt made him Undersecretary of State. In 1800 Canning married Miss Joan Scott by special licence. They were a devoted couple and, soon after the wedding, Canning bought the house at South Hill Park which had been described as 'the most comfortable house you can imagine.' He became close friends with Pitt who visited South Hill Park on at least one occasion.

Canning and his wife moved from the area in 1806 and the house was sold the following year. He continued his parliamentary career but, unfortunately, because of his caustic wit, he differed on many occasions with his colleagues. In 1807 he became the Minister for Foreign Affairs and two years later, in this role, he clashed with Lord Castlereagh, the War Secretary, over his foreign policy. He demanded that Castlereagh resign. When this demand was refused, Canning challenged him to a duel and they met.

However, it was Canning who was injured but not seriously. As a result of the duel, both men were forced to resign.

In 1812 Canning returned to politics and became MP for Liverpool. Ten years later he became Foreign Secretary. In 1827 he reached the heights by becoming Prime Minister although some Tories refused to support him. Among other objections, they felt he was not an aristocrat. As a result, Canning incorporated some Whigs into his cabinet. Sadly, he died the same year, holding office for only 119 days, the shortest tenure of any Prime Minister.

Richard Miller

Richard Miller was a very unpleasant character. Sometime during the eighteenth century, he became landlord of the Hind's Head Inn which had been built around 1465. He and his wife devised an ingenious plan to increase their income. The hostelry was a popular stopping place for wealthy travellers on their way to London or Windsor.

Having recognised an appropriate 'victim', Miller and his wife turned on the charm, produced a delicious meal and plied their unlucky guest with alcohol. Having established that the man was suitably drunk, a maid was instructed to escort him upstairs. He had to sleep in a specific bed because, underneath it, was a trapdoor. A little later, the publican and his wife crept upstairs. Checking that their guest was soundly asleep, they divested the unwary traveller of his money, jewellery and any other items of value that he carried with him. Their newly acquired belongings were then added to the growing pile of wealth stored in a safe place. Returning to the room where their guest still snored happily, Miller released a catch beside the bed. The trapdoor sprang open and the unlucky man was hurled down a steep shaft into the well far below to join the other unlucky travellers who had gone before him.

The staff who worked at the Inn must have been suspicious but they knew their lives, too, would have been in danger had they voiced them. This lucrative form of income might have continued for many more years had a chambermaid not fallen in love with one of the prospective victims, a farmer from Reading. Terrified, she told him of the fate that awaited him.

Her companion hurriedly left the inn in search of help. Finding a group of burly farmhands, he told them of his plight and persuaded them to accompany him to the Inn to arrest the landlord and his wife. His plan was carried out successfully and the two criminals ended their life of crime on the gallows.

DID YOU KNOW THAT…?

In 1798 a Nonconformist church was established in a house. Apparently this was because of the 'general depravity' of the local inhabitants. In 1808 a Nonconformist chapel was built in the High Street. Replaced in 1859 by a Congregational church, this continued as a place of worship for over 100 years until it was demolished in 1968 as part of the formation of the new town.

George Frederick Jackson

Another Bracknell resident was the Arctic explorer, George Frederick Jackson, who was born in Warwick and educated at Denstone College and Edinburgh University. In 1886 he went on a whaling cruise in Arctic waters and in 1893 he journeyed for 3,000 miles by sledge across the frozen tundra of Siberia.

When he returned from this epic journey in 1894, he was asked to lead an Arctic expedition, sponsored by the Royal Geographical Society, to Franz Josef Land in Cape Flora. As they travelled, Jackson mapped the area which was composed of an archipelago of small islands.

On 17 June 1876 Jackson was contacted by the Norwegian Arctic explorer, Fridtjof Nansen, who had been missing for three years and was presumed dead. In his book, *Farthest North*, Dr Nansen describes his dramatic meeting in the snowbound Arctic with the British explorer. He had been lost in the Arctic for three years.

Suddenly he 'heard a shout from a human voice ... the first for three years. Making his way carefully between bergs and ice-ridges, he saw a dark form moving among the hummocks ... It was a dog; but further off came another figure, and that was a man. His surroundings were shrouded in mist shutting out the world around' although through it he glimpsed 'the land, all ice [and] glacier'. He waved his hat and slowly and carefully moved towards the figure whom he recognised as Jackson.

In a typical English fashion, the two men shook hands and greeted each other with the standard, 'How do you do?'

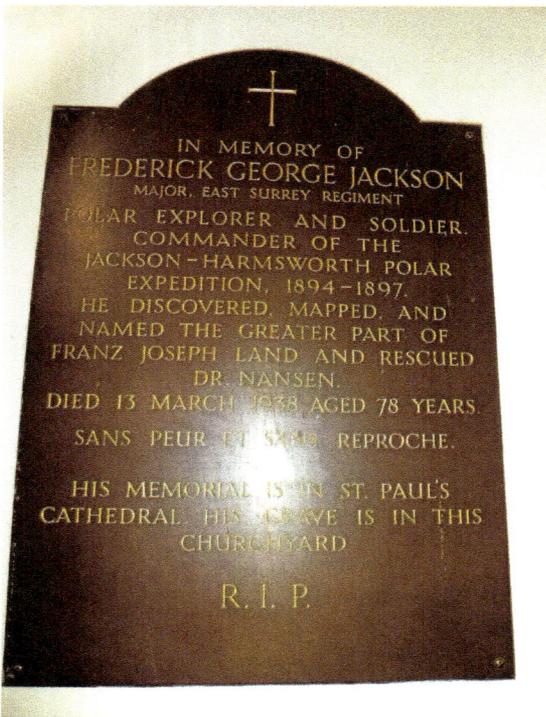

Memorial to Frederick George Jackson.

It was a dramatic meeting reminiscent of Stanley's meeting with Livingstone in Africa. Nansen describes the contrast between his appearance and that of his rescuer:

On one side the civilised European in an English check suit and high rubber water boots, well-shaved, well-groomed bringing with him a perfume of scented soap ... On the other side the wild man clad in dirty rags, black with oil and soot, with long uncombed hair and shaggy beard.

When Jackson had confirmed the name of the man he had rescued, he exclaimed in relief, 'By Jove! I am glad to see you.' No doubt Nansen was even more relieved.

Jackson was later awarded a knighthood of the first class of the Norwegian Royal Order of St Olaf and a gold medal from the Paris Geographical Society.

He died on 13 March 1938 at the age of seventy-eight and was buried in the churchyard of Easthampstead Church under a grave stone that is appropriately shaped like an iceberg. His main memorial is in St Paul's Cathedral but there is also one in the baptistery in Easthampstead. At the end are the words: 'He discovered mapped and named the greater part of Franz Josef Land and rescued Dr Nansen.'

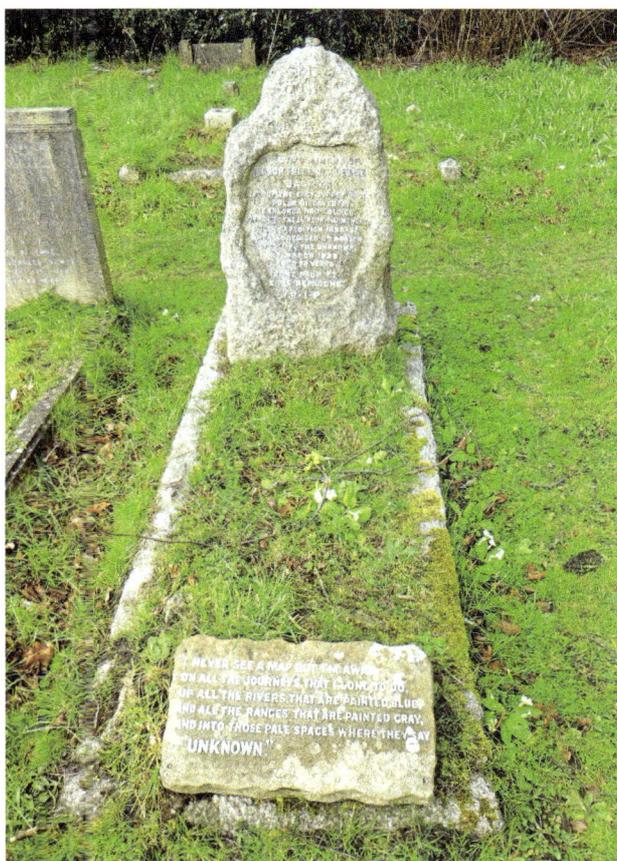

Grave of Arctic explorer, Frederick George Jackson.

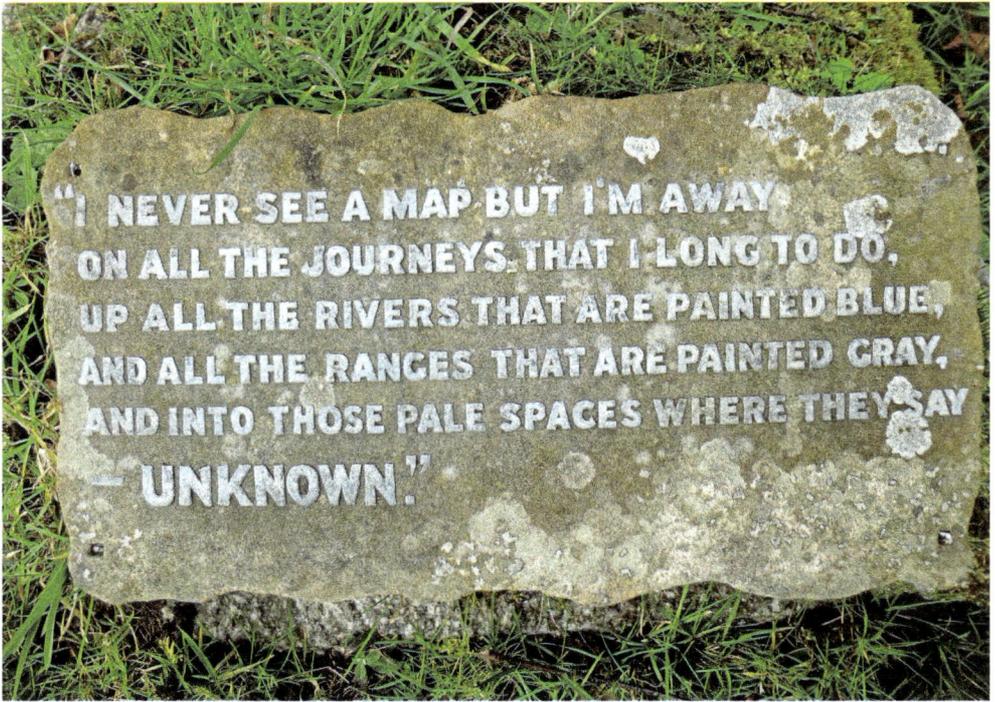

Poem at the end of Jackson's grave.

Thomas Lawrence

Thomas Lawrence was a successful entrepreneur who brought his business to Bracknell in the 1860s. Originally he had worked as a draper in Binfield but he moved to Bracknell and opened a large department store in the High Street. This stocked everything from food to new gadgets for the home. When 'New Bracknell' came into being in the twentieth century, this became Home and Colonial, a food shop. Lawrence also started to manufacture bricks. Brick-making was not new to the area as bricks had been made by using kilns fired by wood. But the coming of the railway opened new possibilities. On 9 July 1856, a branch railway from Staines to Wokingham passed through Bracknell. This enabled clay, the valuable resource found abundantly in the area, to be exploited.

In 1860 Lawrence opened his first brick-making factory in Bracknell. He invented rubber bricks which could be used as moulds. For this he was awarded a gold medal. He continued to expand his business and, by 1890, he had opened several factories including one in Easthampstead. He employed hundreds of local men and was the largest employer in the district. His TLB (Thomas Lawrence Bricks) became world famous. Some were used in the building of the Albert Hall and Westminster Cathedral.

Lawrence made a great contribution to the prosperity of Bracknell in the nineteenth century and is still remembered with affection.

DID YOU KNOW THAT…?

Thomas Lawrence Brickworks became so famous that people came from elsewhere to admire the work done in the factories. In the 1920s, St George's School in Ascot took groups of pupils to visit. Some of the bricks were even sent to Palestine – for part of their journey they had to be transported by camel!

Elsie Suddaby

Elsie Suddaby was born in Leeds in 1893 and became one of Britain's leading lyric sopranos between the two World Wars. She frequently sang duets on the radio with the famous contralto, Kathleen Ferrier. The music world lost a great singer when Kathleen Ferrier died in 1953 at the early age of forty-one. She had a beautiful contralto voice and was sadly missed.

During the 1930s Elsie was equally famous and she gave a number of concerts which were always well supported by her numerous fans. She was known as 'The Lass with the Delicate Air', the title of one of the most popular songs in her repertoire. At the height of her fame, she moved to Hampstead where she lived until the outbreak of the Second World War. When the war started, she decided to escape the Blitz. With a friend, she set up home in Stanley Villas in Church Road in Bracknell where she lived for the rest of her life.

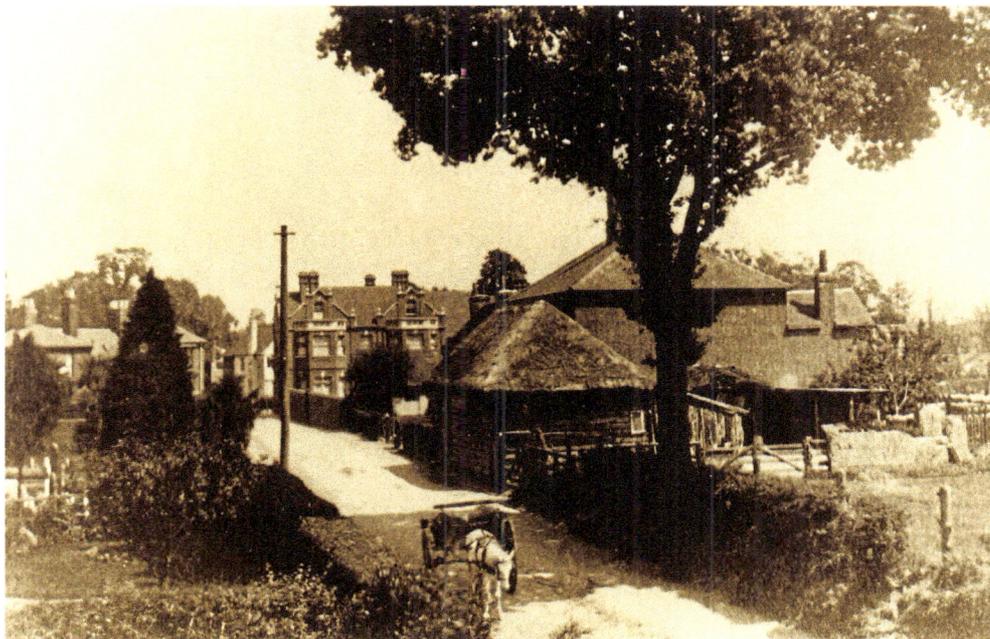

Church Road, 1930s. (Courtesy of Eileen Briggs)

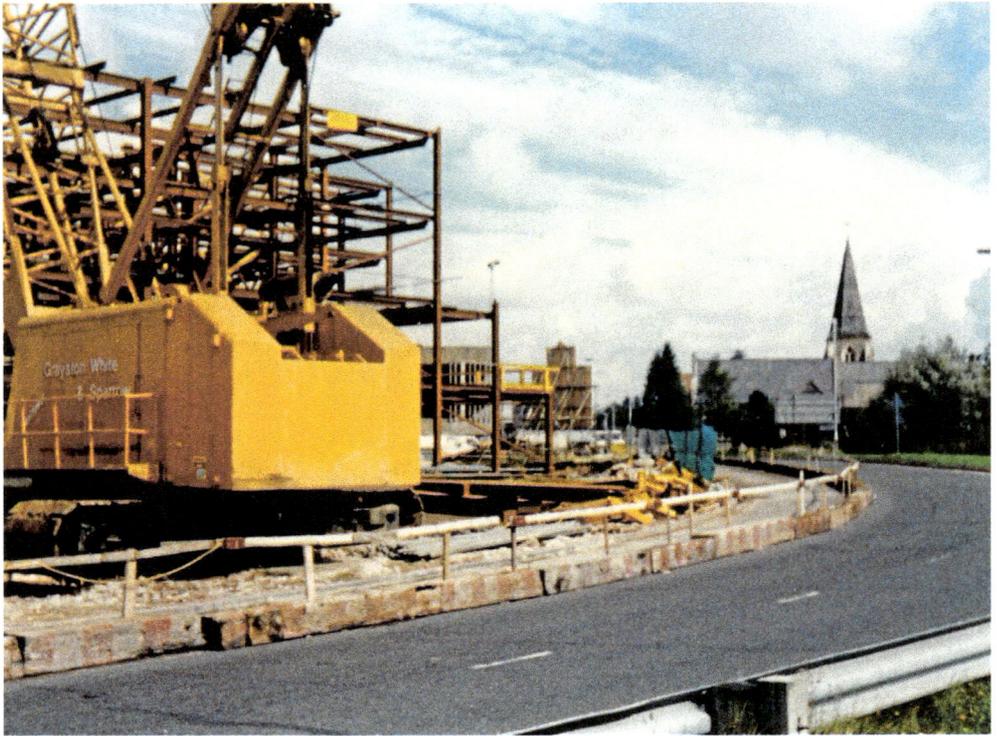

Church Road under construction 1980. (Courtesy of Eileen Briggs)

When the war ended, she sang the soprano part in Vaughan William's *Thanksgiving for Victory* in 1945. The following year, the BBC introduced their Third Programme with a broadcast of John Milton's masque *Comus* and Elsie was the soloist. In May 1951 The Festival of Britain provided her with the opportunity to take part in scenes from Purcell's *King Arthur* at the Victoria and Albert Museum. She also often took part in local concerts in Bracknell and sang the soprano role in Handel's *Messiah.*

Having escaped the Blitz, she was unable to avoid the bulldozers which leapt into action to prepare for the new town in the late 1940s. Sadly, her home at Stanley Villas was one of the victims and she was forced to leave. She lived in Bracknell until she was eighty-seven and died in 1980.

Paul Marlow

Paul Marlow is a very interesting gentleman. He came to live in Bracknell in 1973 and, for over forty years, he has been associated with Bracknell Cricket Club. He has served it as player, coach, umpire and groundsman.

He was educated at Wyggeston Grammar School in Leicester from 1963 to 1970. He played in the school cricket team and was very impressed by Bill Berridge, the groundsman. During the 1969/70 season he played cricket and rugby for Leicester. He moved to Reading in 1970 and studied for four years at the University of Reading's School

of Education where he obtained a teaching certificate. He moved to Bracknell in 1973 and, the following year, he obtained a post teaching foreign languages at Brackenhale School. While there, he studied for an Open University degree, graduating in 1982. He left Brackenhale in 1996 and currently works for the National Foundation for Educational Research which is based in Slough.

In 1974 he joined the Bracknell Cricket Club which was fortunate to have such a talented player on the team. In his debut match in May of that year, he took seven wickets for thirty-eight, a remarkable feat. In 1977 he was elected to the committee and in 1998 he became a life member. As well as bowling, he both batted and kept wicket for the club. At Guildford in May 1979, he and John Harman shared the bowling and wicketkeeping and each took a catch from the other's bowling. In 1982 he started to umpire matches and continues to do this.

During the 1980s and the 1990s he captained the team for several years and in 2010 he had the distinction of being the first player to reach 1,500 runs for Bracknell. He continued to play until 2012. From 1987 to 1991 he was the temporary chairman of the club and vice-chairman from 2003 to 2013 when he left the committee.

It was in 1978 when he took over as groundsman for the club. He modelled his attitude to groundsmanship on Wyggeston Grammar School's groundsman, Bill Berridge. In 2010 after grounds had become officially graded, the Bracknell Cricket Ground received the highest marks that had ever been awarded. Paul continues to keep the grounds in pristine condition.

Paul Marlow, the groundsman, in front of the scoreboard.

10. Weather

A book about Bracknell would not be complete without a chapter about the weather; for the second half of the twentieth century most weather forecasts came from Bracknell. The Meteorological Office, however, did not originate there. In 1854 it was a small department within the Board of Trade. It had started as a service to mariners. In October 1859 the *Royal Charter*, a passenger ship, sank in a violent storm off the coast of Anglesey and all 459 lives were lost. As a result of this disaster, gale warnings were issued for the first time to warn ships of impending storms. The development of the electric telegraph in 1860 made the reception of weather reports easier.

By 1861 there were fifteen coastal stations from which gale warnings could be sent to ships at sea. That same year weather forecasts also appeared in national newspapers. These ceased in May 1866 but were resumed in April 1879. In 1910 the daily weather forecasts in the papers were expanded to include 'outlooks'. The advent of radio and television in the 1920s and 1930s created a wider audience for weather reports. The BBC broadcast the first public weather forecast in 1922, and 1936 saw a weather report appear in caption form on television.

Weather forecasts continued to be broadcast during the 1940s. In June 1944 gales tore across England and forecasters predicted that there would be a storm in the English Channel on 5 June. Unfortunately, this was the day on which the Allies had planned to invade Normandy. They could not risk losing men and ships so the invasion was postponed. It was expected that D-Day would not now take place until the end of June.

However, on 4 June, forecasters noticed a lull in the storm and relayed this to the commander, Gen. Eisenhower. Although apprehensive, the General decided not to wait and the D-Day invasion took place on 6 June. The conditions were not ideal but the Germans were taken by surprise as they had not expected the Allies to risk an invasion in such bad weather. The weather during June did not improve and, unfortunately, the forecasters missed the signs of a gathering storm on 19 June. The Allies were not warned of this and, consequently, many ships were lost but fortunately this did not affect the ultimate result. After the war, there were more cold winters and 1947 became one of the coldest on record with continuous snow. Radio and newspaper forecasts continued and finally, in 1954, live weather forecasts were made on television.

By the 1960s there were branches of the Met Office in Kingsway, Harrow and Dunstable. At this time, the weather forecasts came from Dunstable. The three offices were amalgamated in November 1961 when a building was specially designed to house all departments in the new town of Bracknell. Before long, computers had been installed and pictures from satellites were being received. More sophisticated equipment was installed in the 1970s and by the 1980s the Bracknell Meteorological Office was providing forecasts for civil aviation around the world; over 1,000 personnel were employed throughout the building.

Bracknell continued to provide weather forecasts until 2003. In September of that year, the headquarters of the Met Office was moved to a new purpose-built construction in Exeter. This was officially opened on 21 June 2004.

As Bracknell is almost synonymous with weather, it is not surprising that there have been some strange weather phenomena during the twentieth century. The end of the nineteenth century saw the temperature drop to below freezing during the winter months; it was so cold that the River Thames froze, entombing boats in the ice for some time and providing a natural ice skating rink.

The beginning of the twentieth century was also cold. 1900 had been a dry summer and, in Bracknell, mild weather continued until the New Year when winter hurtled in during February and the town became hidden under 9 inches of snow. For the children, snowballing became a pleasant pastime but struggling to work or to buy food was very difficult for the adults. For the first half of the twentieth century Bracknell's weather varied little from the rest of the South East.

February 1959 saw thick fog and it was a time that one resident will not forget in a hurry. She had dinner in nearby Warfield and, although the fog was thickening, she decided to drive home knowing that she had a full tank of petrol. That was a mistake. The fog increased, pressing in on her car crawling along, she had no idea where she was going. She continued for several hours before, inevitably, the car shuddered to a halt. She had run out of petrol and it was 3.00 a.m.. Finding a torch, she started to walk, hoping it would help her to keep warm. The dense fog was starting to thin as she staggered on and eventually saw a moving light held by a farmer who was about to start milking his herd of cows. He made her a welcome hot drink and offered her a couch to sleep on for the remainder of the night. The following day the fog had dispersed and her host drove her home. Her abandoned car was later discovered on the outskirts of Bracknell, miles from her home.

The summer of 1959 was very hot and it was an important time for Bracknell as work started on the new headquarters of the Meteorological Office on the roundabout which is still known as the 'Met Office Roundabout'. It still retained the name even after the Met Office had relocated to Exeter. Because of the heat that summer, there were a great number of fires and the Bracknell Fire Brigade was kept busy. They were called out 203 times; the previous year there had been only ninety-two emergencies.

The 1960s provided Bracknell with some interesting weather stories. A gardener from Church Road had a lucky escape in June at the beginning of the decade. He had taken refuge from a vicious storm in a garden hut. Then, thinking that the rain had eased, he left his shelter and walked towards the house. As he did so, there was a blinding flash of lightning followed by a tremendous crash. Turning round, he looked in horror at the hut he had just left. The lightning had struck a nearby tree splitting it from top to bottom and hurling it on to the roof of the hut. He would not be able to seek refuge there again.

The first day of November 1961 was an important time for Bracknell as the new headquarters of The Meteorological Office were finally opened; computers and other machines were installed and Bracknell was ready to relay weather forecasts to the world. She would also be blamed if the forecasters made a mistake. The power cuts in 1963, suffered by the whole country, must have been a very difficult time for the Met Office

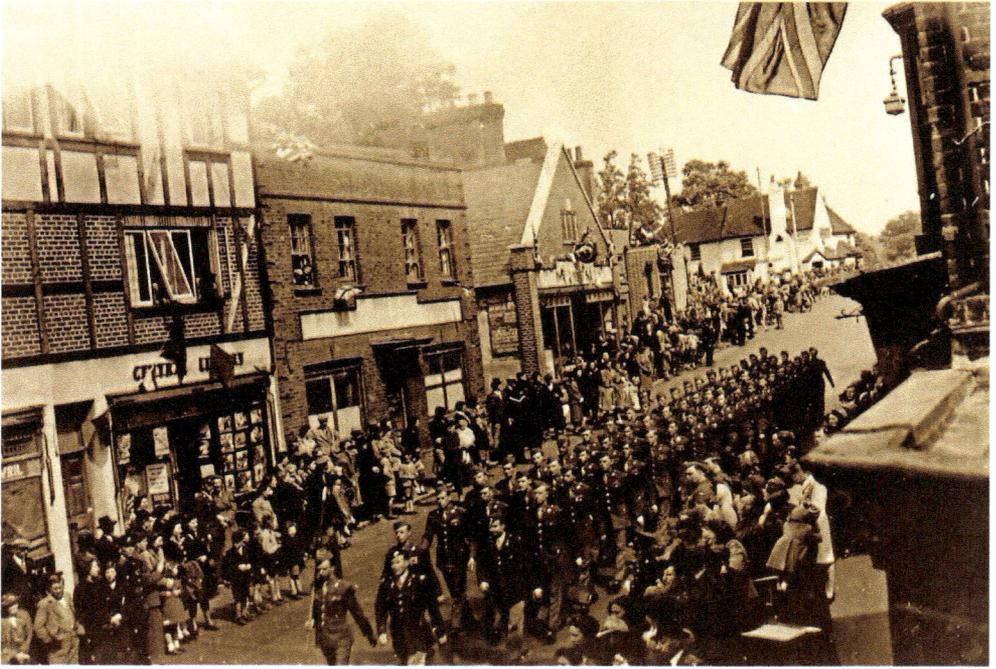

G.I.s in the High Street, 1940s. (Courtesy of Eileen Briggs)

Two views of the High Street – left: 1950s; right: 1960s. (Courtesy of Stephen King)

New gateway to High Street, 2016.

as its computers and electronic machines relied on electricity. In what was the coldest winter since 1740, a Bracknell plumber was called out eighty-one times over a period of thirty-six hours. As in 1947 there was continuous snow.

Easter Monday in 1967 was spoilt for one Bracknell resident when he was sure he could smell the revolting odour of crude oil. Apparently, a ship, wrecked on the Seven Stones Reef at Lands End, had spilt its cargo of crude oil and the winds had wafted the smell all the way to Bracknell. A climax was reached during September of that year when tornadoes were reported by the Met Office.

Easthampstead could have been in the record books in the 1970s. In January 1971 the temperature there reached an amazing 14°C (57°F) and, in December 1976, the same area dropped to a record –10°C (14°F). This was the lowest temperature recorded in the country during that year.

June 1977 was a month that the workers at the Met Office would no doubt prefer to forget. On the night of 13 June, there was a violent storm which disrupted their computers so weather forecasts had to be suspended until the engineers could repair them. January and February 1979 were the coldest months recorded since 1963 and Bracknell was snowbound for most of the time with the temperature dropping to a chilly –4°C (24°F) and ice crystals falling at the end of January.

During October 1987 there was unprecedented rain and the Met Office warned that floods in certain areas were imminent; the appropriate authorities consequently started to prepare. On the afternoon of 15 October, the duty officer at the Met Office prepared the weather report and tried to be as accurate as possible. A storm was definitely approaching England and strong winds were blowing from Europe across the English Channel. However, he was not convinced that the winds would affect England. Consequently, he warned the BBC of floods but underplayed the risk of strong winds.

That evening Michael Fish, the BBC weather forecaster, therefore announced to the public that 'the weather will become very breezy in the Channel but there will not be a hurricane.' The following morning the country woke up to discover trees littering the roads, lorries and cars overturned, roof tiles flung into gardens and even some church steeples had been hurled to the ground. The winds from Europe had devastated southern England. The media were furious with the weathermen at the Met Office and the papers' headlines shrieked, 'Why weren't we warned?' Ironically, the storm had also disrupted the telephone lines at the Met Office so they were unable to respond. Michael Fish was, of course, blamed for his misleading report. However, the Director General of the Met Office eventually defended the weather forecaster, 'He said there would be no hurricane and there was no hurricane.' He explained that a hurricane is a tropical storm and never occurs in Britain because hurricanes can only happen when the sea temperature is 26 °C or above. This never happens on the British coast. In spite of this, 'hurricane' still seemed an acceptable word to the general public as the damage from the strong winds was repaired. No doubt the officer on duty on that historic night was suitably dealt with but it would be many months before that particular faux pas was forgotten.

Notes

1. History of Bracknell
1. The Victorian Trade Directory.
2. The 'Sperry Gyroscope' had been created in 1913 to manufacture the gyrocompass recently invented by Dr Elmer Sperry.

2. The Royal Connection
1. The battles between the Houses of York (white rose) and Lancaster (red rose) took place to secure the throne of England. These started during the reign of Henry VI and came to an end in 1486 when Henry VII, who had been the Duke of Lancaster, married Elizabeth of York thus uniting the two warring families.

3. Easthampstead
1. Manor: an area over which a feudal lord ruled and received taxes from his tenants.
2. Hide: a measure of land that would support a family.
3. Edward the Prince of Wales, who later became Edward VII, and his wife stayed in Easthampstead Park during Ascot week in 1877 and also in 1885.
4. In 1902 the 6th Marquis of Devonshire created a scandal when he sued his wife, Catherine, for divorce on the grounds of adultery. In spite of her pleading for forgiveness, he ignored her and, a few months later, she remarried. In May 1907, the Marquis also remarried.

4. Ranelagh School
1. A guinea was twenty-one shillings.
2. Putting pupils in classes according to ability.
3. The examination that preceded O-Level.

5. Bracknell's Ghosts
1. The dressing room used by the actors.

6. South Hill Park
1. The Victorian Trade Directory.

7. Pubs and Roast Dinners
1. A guinea was worth £1 1s. There were twenty shillings to a pound.

8. Entertainment and Leisure

1. Old Moore's Almanac was first published in 1697 by Francis Moore, an astrologer, who served at the court of Charles II. The first editions contained weather forecasts. The Almanac is still published today and predicts world sporting events.

2. A map and a compass only are used to pinpoint places in the area.

Bibliography

Allen, Richard, *Ranelagh: A History* (2000).

Boyd, Alison and Outi Remes, *The History of South Hill Park* (Bracknell Forest Council: 2010).

Briggs, Eileen, *A Backward Glance* (The Book Guild: 1998).

Collins, Diane, *Easthampstead: Its Manor, Church and People* (Juniper Publications: 2000).

Currie, Ian; Davidson, Mark and Egley, Bob, *The Berkshire Weather Book* (Froglets Publications: 1994).

Ditchfield, P. H., *Bygone Berkshire* (William Andrews & Co.: 1896).

Hickson, Colin, *Bygone Bracknell* (Phillimore: 1984).

Long, Roger, *Ancient Berkshire Inns and Their Stories* (TWM Publishing: 1996).

Martin, Donovan, *A History of the Ranelagh Foundation* (Bracknell: Bracknell Press, 1959).

Middleton, Tom, *Royal Berkshire* (Barracuda Books Ltd: 1979).

Oliver, Luke, *The Royal County of Berkshire* (Cliveden Press: 1995).

Parris, Henry and Parris, Judith, *Bracknell: The Making of Our New Town* (Bracknell Development Corporation: 1981).

Pooley, Lee, *Bracknell Before the New Town* (Bracknell: Allen Sharp, 1970).

Acknowledgements

Mr John Bassett
Mrs Eileen Briggs
Mr Mike Stevenson
Mrs Maggie Stevenson
Bracknell Library
Mrs Beverley Stevenson: Head, Ranelagh School
Ms Sarah Castle: Librarian, Ranelagh School
Wetherspoon Pubs
U3A Bracknell Forest Local History Group
Bracknell Forest Society
Mrs Pamela Jackson
Mr Richard Allen
Mr Paul Maslow
The staff at the pubs mentioned who often provided interesting information.